PENRYN
From Old Photographs

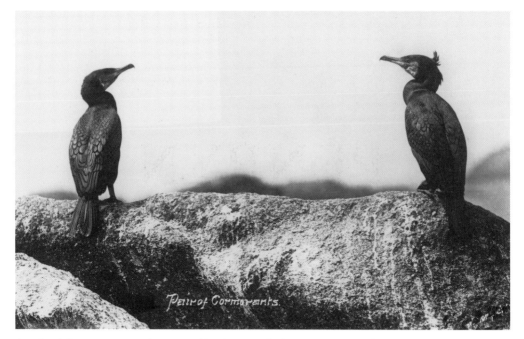

A pair of Cormorants are shown on this photograph, from it can you tell me Penryn's nickname and why? The first person to telephone me living outside the area will receive a free copy of my next Penryn book.

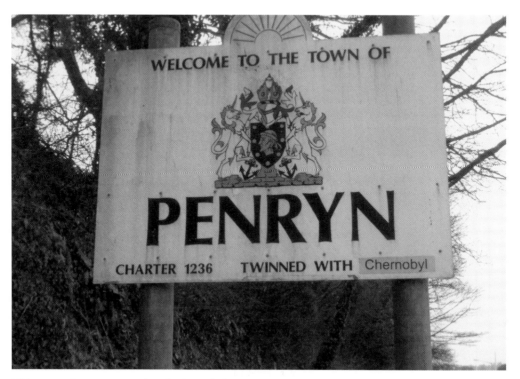

Welcome to Penryn, twinned with Chernobyl.

PENRYN
From Old Photographs

ERNIE WARMINGTON

AMBERLEY

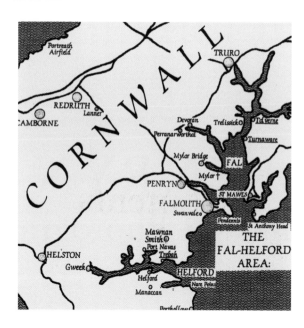

Dedicated to the young men and women in both world wars that left Penryn, some never to return, that you can read and that I don't have to write in German.

First published 2002
Revised edition published 2015

Amberley Publishing
Cirencester Road, Chalford
Stroud, Gloucestershire, GL6 8PE

www.amberleybooks.com

British Library Cataloguing in Publication Data.
A catalogue record for this book is available from the British Library.

ISBN 978 1 4456 4385 4 (print)
ISBN 978 1 4456 4412 7 (ebook)

Typesetting and Origination by Amberley Publishing.
Printed in Great Britain.

Contents

Acknowledgements

This, with another to follow, is my sixth book; five are about Penryn, the other being about old Cornish transport a subject in which I have a great deal of interest in.

I was born and schooled in Penryn before moving on to Technical College Falmouth Camborne. After serving a five-year apprenticeship at Falmouth Docks and then I joined the British Tanker Co. and, a little while later, joined the New Zealand Shipping Co. where I ended up a senior watch-keeping engineering officer, tramping all over the world, around the capes and through the Techinical College as an engineer canals. After seven years at sea I came ashore, married a Camborne girl and worked for British Telecom until I retired. Now living in Redruth, a little plot of land awaits me near St Gluvis Church for when the time comes.

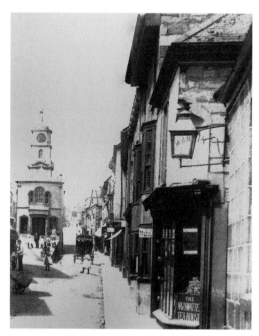

Penryn Lower Market, 1897.

It is almost impossible to know all about my home town and surrounding area however, though there is always someone to whom one can turn for more information. It is these people I wish to thank for their help in naming names and places and providing the stories that go with them, especially my wife Rosemary for the typing and for putting up with a disrupted household. I also thank the new-found friends in the outlying villages. For any names I have spelt incorrectly, any places or dates I have got wrong and to anyone who I have missed out, I apologise.

Mr and Mrs R. Lee, Mr and Mrs R. Hilder, Mr and Mrs T. Toy, Mrs R. Woods, Mrs P. Kerslake, Mr and Mrs D. Dancer, Mr and Mrs J. Basher, K. Kneebone, Paddy Bradley, M. Sanders T. Dungate, J. Tregonning, R. Rasheigh, Mr and Mrs C. Willey, L. T. Williams, C. Tremayne, V. Tullin, C. Lang, Viv Wilson, P. Welch, G. Jacket, K. Bryant, N. Young, M. Caddy, R. Doney, D. Wiles, M. Edwards, Mrs R. Collins, Mrs Perham.

Introduction

With a population of 6,500 and growing, the proud and picturesque port of Penryn covers some 900 acres and stretches over three sides of a wooded valley at the head of the Penryn River that flows down into Falmouth harbour. One of the most ancient boroughs in Cornwall, Penryn is steeped in history and can trace its history back as far back as a recording in the Domesday survey of 1086 through a part of the town known as Treliver. The first charter for markets was granted in 1236 after the town was founded by an Italian Bishop of Exeter, having two members of parliament as early as 1547. During the reign of James I in 1621 it received its first charter as a borough, making Sampson Bloyes its first mayor.

The real beginning, however, resulted in the building of the great collegiate church of St Thomas of Glasney in 1265 by Walter Bronscombe, Bishop of Exeter. During an illness he dreamed of constructing a religious college on a six-acre site on marshy land. The priory was completed in two years using some local granite and labour – stone from Caen in Normandy as well as from Beer in Devon – and documented 1334. It was built with three fortified towers and a chain across the head of the river to protect it from surprise attack by French and Spanish pirates.

This established the town as the ecclesiastic capital of Cornwall. Had the town not been suppressed and closed during the reign of Henry VIII, Penryn would, without any doubt, now be Cornwall's cathedral city and not Truro, as now. Following the Dissolution, the church silver was sold off and the buildings dismantled and sold. The Isles of Scilly received the lead from its roof. Much of the better and finer worked stone was used to build prominent buildings and homes locally. A large amount of finely cut and shaped stone can be seen in the town's museum.

As a sea port the town had little trade in the fourteenth century but later in the Tudor period, along with other ports in the area, Penryn recorded as much trade, and in some cases more, than other ports in the country.

Later, in the seventeenth century, the Redruth–Camborne area began to develop a tin and copper mining industry that brought prosperity to the town once more, with the port handling huge amounts of tin as well as flour, gunpowder, fruit, meat, live cattle, Peruvian guano, coal, wool, paper, etc.

Returning from a voyage of discovery from the West Indies Sir Walter Raleigh stayed at the home of Sir Peter Killegrew, Arwenack House. He saw the need for a supply of food and lodgings for returning seafarers. Sir Peter Killegrew recognised this potential and somehow managed to move customs due from Penryn to the newly developed hamlet of Penny-Come-Quick.

The citizens of Penryn and Truro petitioned James I without avail, though he agreed to the building of Falmouth port, which was then granted its first charter in 1661 making Penryn around 400 years older than the new upstart, Falmouth. The founding of Falmouth port caused a serious decline in trade for Penryn, however, prosperity returned in the nineteenth century with the arrival of the granite industry. Alongside the Penryn river a Scotsman named John Freeman had set up a business in granite dressing, huge deposits of the finest stone lay just below the surface in the small villages around Penryn in Mabe and Constantine in particular.

The stone was quarried and carried to the worksite by horse and cart; this was later achieved by steam traction engine, and eventually with contemporary lorries. Penryn then were shipped from these quays became known as the 'Granite Port'. Large quantities of shaped stone for use in shipyards, the construction of London buildings and monuments not only in this country but abroad as well. It grew to become a huge industry, employing hundreds of men from the surrounding villages in the nearby quarries as well as in the works on the Falmouth road.

The sheer amount of shipping that passed through the port of Penryn in the 1880s brought with it increased trouble from fighting, rioting, prostitution around the many inns, taverns and ale houses some only a few yards away from Exchequer Quay. At one time there were as many as thirty drinking houses and hotels in the district. Reports in the local papers around 1840 stated that in several Cornish towns a gentleman could be accosted by no less than forty ladies of the night within only a few hundred yards. One can only assume that Penryn would have been the same.

The *West Briton* reported in 1869 that

No town in the Western Counties has been flourishing more during the past year as Penryn. Its steam engines are working flat out employing large numbers of men earning 5-6s per day. Two thousand, five hundred head of cattle have been imported plying constantly between Penryn, Spain and France. An iron foundry established a few years ago by Mr Sara has been fully employed, Mr Mead's paper mills were also doing well. The potato trade has not done so well as former years owing to the excellent English crop. The fruit trade from the orchards and gardens were finding a ready trade from the great number of vessels constantly arriving and departing the port. Tanyards, coal stores, lime kilns and flour mills also placed the town commercially in a very healthy state.

A health report from 1870 stated that, in many instances, the street gutters of Penryn had been so placed that fluids soaked into the foundations of the houses. While there was a groove cut into the centre of the pavement for walkers, the deposited waste still cut the air with a stench. The roads were largely neglected, filled with stagnant pools of decomposing vegetables and other filth; this was compounded by people's habit of emptying the contents of privies, middens, and cesspools into the street gutters leaving the excrement to be casted away. Behind the houses and homes that lined the streets were many that were blighted by refuse and poverty and unfit for human habitation. The arrival of the 1900s brought with it two world wars in which many hundreds of brave men left Penryn to fight for their country. Though some came back, many didn't. Those men lucky enough to return went back to their old jobs with Freemans, Falmouth Docks and other works in the area. This period also saw the birth of the era of concrete which, in turn, precipitated the decline of the granite trade that caused Freemans to close in 1965. Today, the local quarries still produce stone for facing buildings, road building and for reconstituted stone.

I don't expect to be around to commemorate the anniversary of end of the Second World War in 2045 so I have taken the opportunity to write about it in this book.

I hope you enjoy this one as much as I have enjoyed compiling it.

CHAPTER ONE

Religion, Houses and Streets

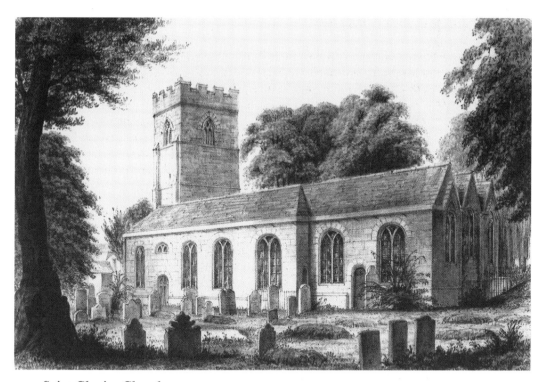

Saint Gluvias Church
Built from local granite stone and consecrated by the Bishop of Exeter, Walter de Stapledon, in 1318, St Gluvais church is built on earlier foundations which could date as far back as the sixth century.

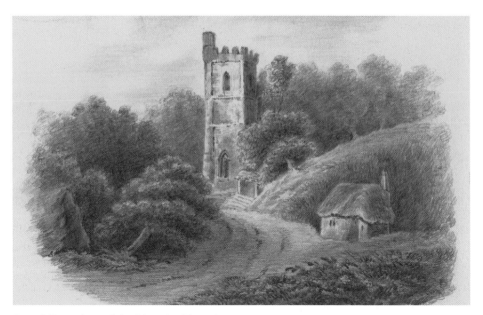

Pencil Drawing of St Gluvais Church
This lovely undated pencil drawing by an unknown artist is of Saint Gluvias Church. I can only imagine it was meant to go back a few hundred years. The little thatched cottage is no longer there although the lynch gate is. The Enys family worshipped there every Sunday coming from their estate a few miles away.

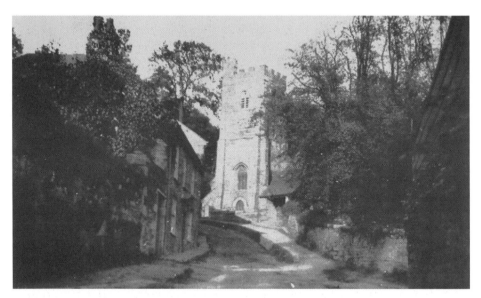

St Gluvais Church, Looking up the Hill
In this photograph, from another era, a wall has been built were the cottage was and homes built opposite. In 1948, just after the Second World War, death watch beetles were found in the belfry and the bells declared dangerous to ring. Following a single donation and generous contributions from a further two families, new frames were made and the bells restored by Taylors of Loughborough. An additional bell was also installed, adding one more to the peel.

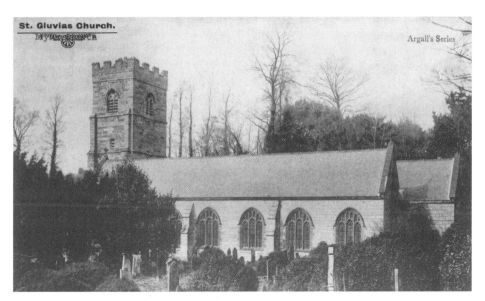

St. Gluvias Church.

Argall's Series

St Gluvais Church and Churchyard

This postcard looks at St Gluvais from the south side of the churchyard. The church was very lucky during Second World War. Once, when living on the terrace and sheltering from an air raid, I saw a landmine come down on a parachute, landing a few hundred yards from the church without exploding. The bomb was dealt with by a naval disposal team. The next day (a Sunday), the church was closed to worshippers for the first time in its history.

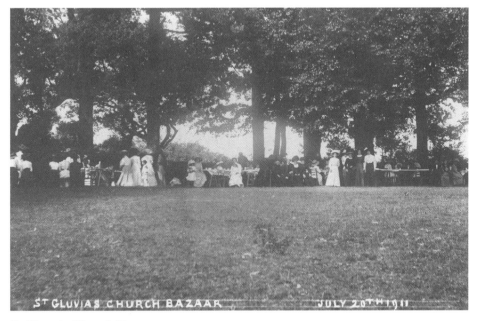

ST GLUVIAS CHURCH BAZAAR JULY 20TH 1911

St Gluvais Church Bazaar

This photograph shows female revellers looking splendid in their long, flowing dresses and matching hats with the sun shining through the trees. The ladies seen sitting on forms are tucking into traditional Cornish food in this bazaar around 1911.

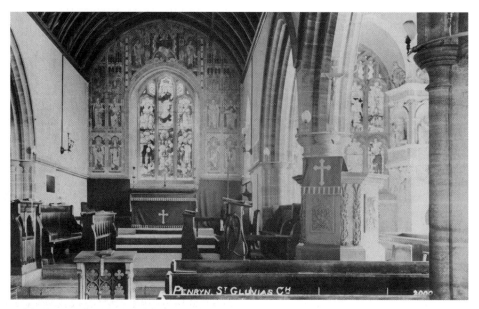

St Gluvais Church, Interior

With beautifully carved wood and stone, the interior of the church really looks splendid with the sunlight shining through the stained glass windows. Gas lighting was removed and electric light installed during alterations around 1950.

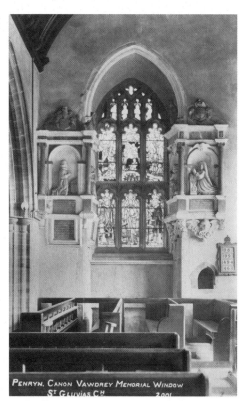

Canon Vawdrey Memorial Window

The stained glass windows were replaced after being removed during the Reformation. As well as this church, and the Catholic church at Glasney, the people of Penryn had their own chapel of St Mary which stood in the middle of the main street. It was built with £20 obtained from the sale of jewels and plates from the surrounding churches.

Methodist Chapel

With the Methodist Chapel in Chapel Lane, built in 1789, being deemed too small, despite having been extended several times because of the growing population, a new place of worship was sought. The architect J. W. Trounson was appointed to oversee the construction on land acquired in the main street. Built by Carkeek of Redruth using local granite from John Freemans, the chapel's construction cost £5,000. It was opened in 1893.

Captain Charles Squib

The Salvation Army opened their premises in Penryn on 4 June 1882. They obtained a little hall behind the houses in the main street at which they enjoyed a great following. I lived opposite the hall and attended Sunday school there as a youngster; Nora Hellard, a well-known Salvationist, would take me. I liked the harvest festival and had a Dickens of a time when trying to explain to my mother about the grapes that were 'up on high'. The picture shows Capt. Charles Squibb, married to Capt. Mary Pamela Sampson, who came to Penryn from St Just in May 1934 and lived at No. 94 Market Street before leaving for Devonport in May 1935.

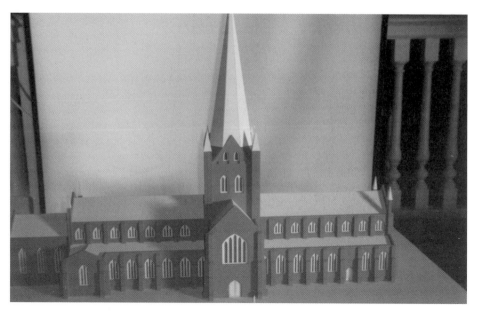

Glasney Collegiate Church Model

Earlier, in the introduction, you read about the Collegiate Church which was built at Glasney in 1265. This picture shows a model of the building that was made by two university students at Tremough. Experts suggest that it looked like Exeter Cathedral, the model can be seen on display in the penryn Museum.

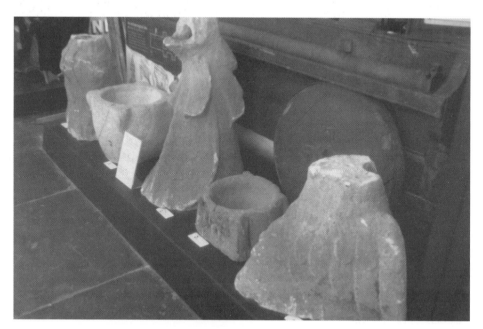

Carved Stone from Glasney Collegiate Church

Some carved and dressed stone from either Caen (Normandy) or Beer (Devon) that is thought to have been used in the construction of Glasney Collegiate Church. The stones can be seen on display in the Penryn Museum.

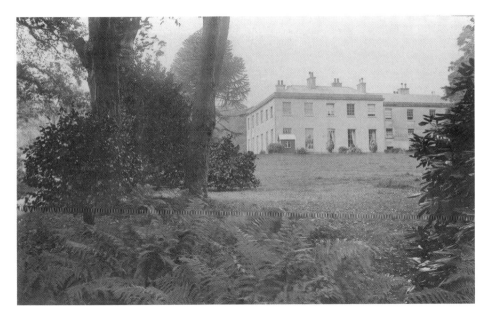

Enys Estate

Enys Estate, a few miles outside Penryn, has been the home of the Enys family since the reign of Edward I. It is noted for its lovely gardens and for the house's unique arrangement, it having been constructed in the shape of an 'E'.

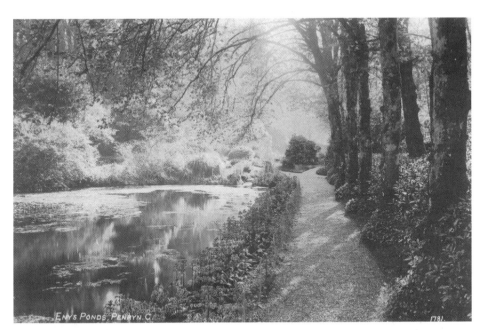

Enys Mansion Ponds

The Mansion burnt down in 1826, after which (in 1830) another house was built for the Enys family costing £6,500. To ensure that, in the event of another fire, there would be sufficient supply of water a number of fresh water ponds, lakes and reservoirs were constructed on the estate. These were later filled with fish.

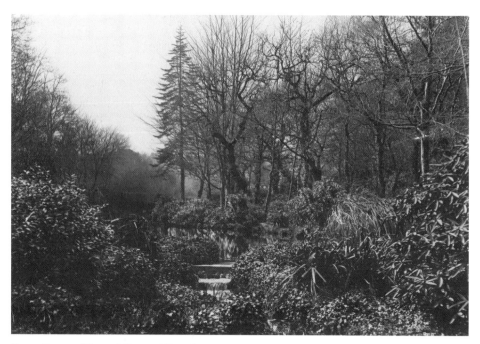

Enys Estate Waterfalls and Ponds

Samuel Enys was MP for Penryn in 1660 and Sheriff of Cornwall in 1709. He was a heavy gambler at cards, cock fighting and dice, losing more than he ever won. This photograph is of the water falls in the Enys Estate and ponds.

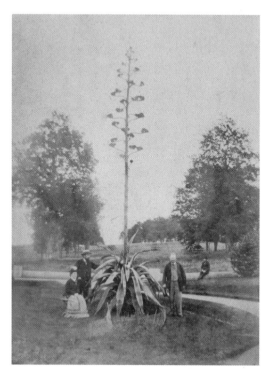

Enys Estate Grounds

When John Enys died in 1802, after inheriting the Estate from his Father, it passed to Frances his second son. This picture shows another part of the Estate. Outside the big house stands this huge Aloe in flower. The Dutch Navy were stationed here during the Second World War (see Chapter Two).

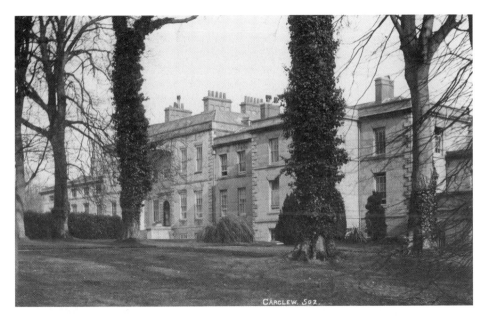

Carclew House

Carclew House was the home of William Lemon who bought it from James Bonython, a Truro mine owner and merchant, in 1760. His grandson William Lemon, who was later knighted, passed it on to this second son, Sir Charles Lemon, in 1824. He was initiated into Freemasonry in 1840, becoming master of the Love and Honour Lodge in Falmouth in 1843. The photograph above shows that beautiful Mansion.

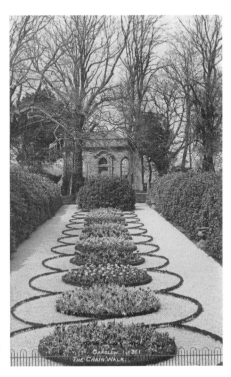

Carclew House Gardens

Sir Charles Lemon became Provincial Grand Master of the Freemasons in 1844 and died at Carclew in 1868. His nephew, Col. Arthur Tremayne, was the next owner and passed it on to his son, William Tremayne, in 1905. The garden and estate was looked after by a head gardener by the name of Luscombe. The photograph to the right shows how perfect the garden and chain walk must have been under his guidance.

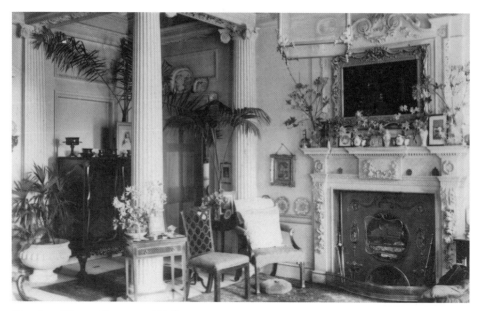

Carclew House Entrance Hall

This postcard, dated 1915, shows the entrance hall at Carclew where guests would have been met by the butler or a member of the family. The estate was quite extensive and full of deer. Sir Charles Lemon is known to have grown a fine selection of rhododendrons which was, at one time, no doubt well-worth a visit.

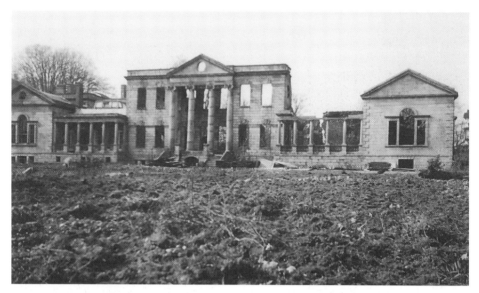

Carclew House Fire

In the early hours of the morning on 5 April 1934 a mysterious fire broke out. Capt. Tremayne, his guests and family, who are said to have escaped from the house in their night attire, were forced to watch the house as it burnt to the ground. The Tremayne's chauffeur had to drive to the nearest fire station to summon fire brigade, who came from as far as Penryn, Falmouth and Truro, because the telephone lines had been destroyed by the fire.

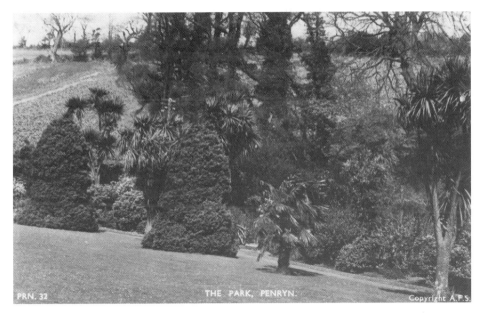

Trelawney Park

Trelawney Park, on the boundary between Browns Hill and Commercial Road, was once known as Durggan Moor. It was owned by Mr Mitchell who leased it to Mr Martin who used it as a smallholding for growing fruit and vegetables; it also had a deep stream running through it. When Mr Martin's lease expired, Mr Mitchell gave it to the Council for the people of Penryn for a pleasure park.

Trelawney Park

The town surveyor, J. H. Harris, stated that the conversion of Durggan Moor into a pleasure park and tennis courts would cost £340. A large proportion of the finances for conversion, £300, were bequeathed by Joel Mitchell, an ex-Mayor in around 1885.

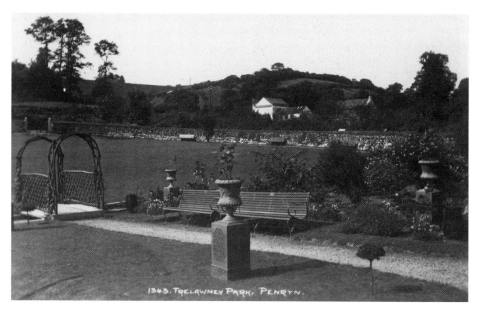

Trelawney Park Opening

The park was officially opened by Mayor C. W. Andrew at 7.00 p.m. on 5 May 1926. Imagine the procession marching through the town headed by the town band: the Sergeant-at–Mace, followed by the Council dignitaries, fire brigade, police, and children from the schools carrying flags.

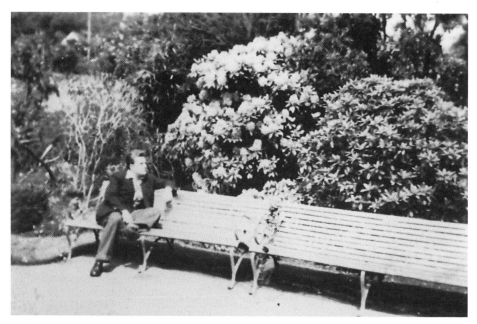

Bird Watching in Trelawney Park

With the tennis court now open, Doctor Blarney and his party found playing doubles matches at the park exhilarating. At a council meeting E. H. Chegwidden, an ex-service man with a wife and children, was elected the first groundsman. He always told us off as boys when we tried to play either football or cricket. The photo shows yours truly bird watching.

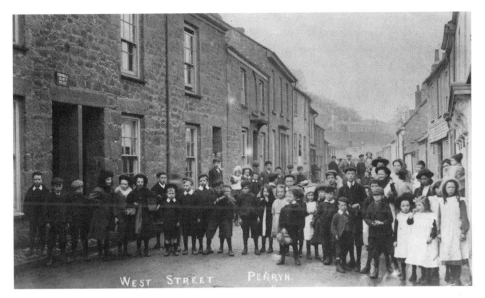

West Street, 1909

Over the years the street has been known by two other names, Calver Street and Pig Street. My father's family lived at the far end of the street, at No. 44, with his mother, father, brother and sister. I wonder if he is here somewhere in this photograph. They are all well dressed and are keen enough to have their photograph taken. Above the door on the left a notice reads 'Cornwall County Police', perhaps that is why the children are behaving themselves.

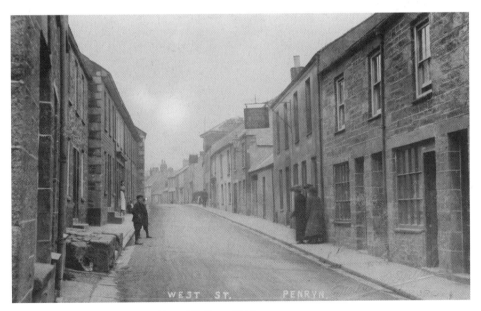

West Street, Pubs and Welfare Hall, *c*. 1910

Two women are in a hurry in this photograph, perhaps the Three Tuns is about to open. The Fifteen Balls is a little further along on the same side; next to it is the Welfare Hall (built later), at the point where the road begins to bend. The Co-op had a general store; I well remember going there to shop with my mother's order for groceries with her Co-op number 28–22.

Looking Down Truro Lane from the Main Street

Years ago, in the mid-1840s, a mail coach pulled by horses would gallop up the main street turning down this lane to Enys House and beyond. The lane is a lot steeper than it looks, I think it is too steep and narrow. I'm inclined to think that the mail coach would go down St Gluvias Street (opposite the town clock), where the road is not so steep and wider, turning left at the bottom along to Truro Hill and on to Enys House and the other estates.

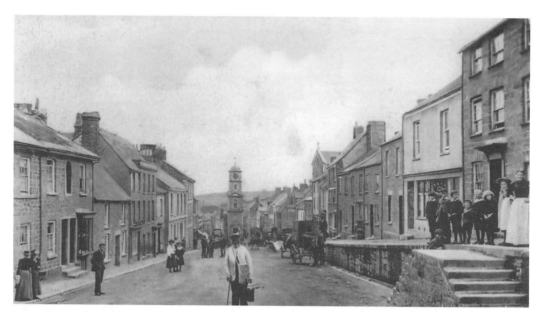

Main Street Clock

This photograph of Penryn's main street, taken sometime before 1909, looks towards the clock tower, which was added to the market house in 1839. To the right can be seen the Wesleyan Chapel. Next down from the shop is a little cottage that has since been demolished to make a new entrance to the council school. My bedroom was the second complete window at the top right; a smaller window, at a right angle to this, allowed me to see the clock face and ensured that I was never late for school.

Chapel Lane

Turning right at the Seven Stars public house in the main street leads you to Chapel Lane. Mr & Mrs Thorneycroft are seen standing proudly outside their little cottage. At the end of the row of cottages a set of gates can be seen that mark the entrance to the council school, which was where the old Wesleyan Chapel once stood until it was moved to new purpose-built premises.

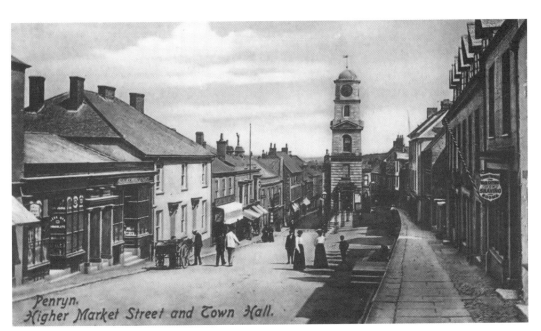

Penryn Higher Market Street and Town Hall I

It must have been a nice, sunny day in 1908 when this photograph was taken in the main street. On the right can be seen Mr Thomas' barbers shop. As was common with most barbers at the time, he did shaving and also let out rooms. On the left is Mainwaring's grocery and, further down, Harry Moon's, whose sun blind is keeping the sun from fading the clothes he sells.

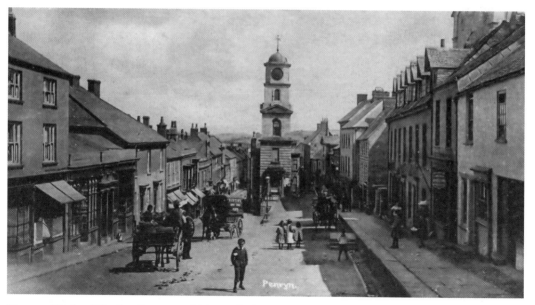

Penryn Higher Market Street and Town Hall II
Martins' horse drawn wagon looks to be on a delivery in this photograph as it is seen coming up the main street on another sunny day. Nearby, a horse drawn carriage waits to be hired outside the Methodist Chapel.

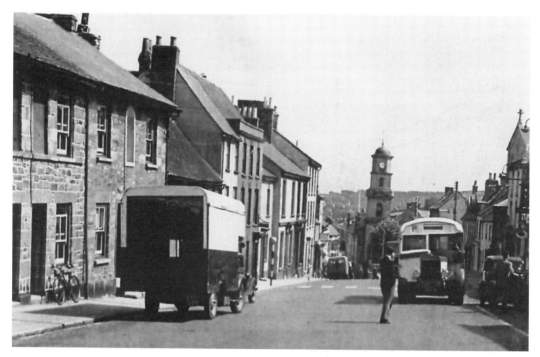

Penryn Main Street
There are several means of transport in this photograph: bicycles, cars, buses, vans and, of course, shanks' pony (walking). The Belisha crossing is still there today, the little car on the right (seen outside the Seven Stars public house) was run for many years by George Foulks and his wife Peggy.

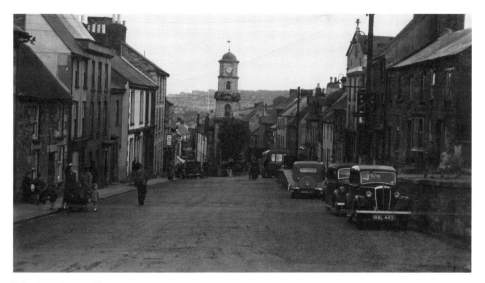

Market Street I

This photograph, taken from more or less the same position as the last photograph, shows a local bus about to set off for the Falmouth area. The lovely cars parked on the right-hand side are unperturbed by yellow lines. The cars include: a Morris Saloon BAL 443, a Ford model C, and a Rover VH 830. On the terrace two little girls and a boy can be seen outside the gates of the council school yard.

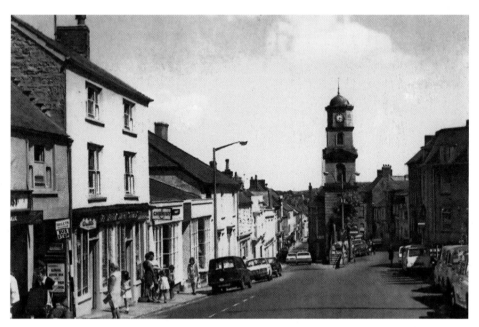

Market Street II

The same scene a considerable number of years later. The shape of the cars pictured date this to the 1960s, unlike now, the shops in the background are open for business. On the extreme left is Dicky Paul's newsagents and behind the bus stop next to it is Mainwarings' grocery, then Hutts' chemists.

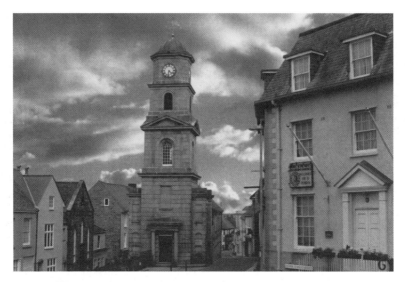

Market Street III

This photograph shows the council offices (seen on the right). It was here that an opening was made by demolishing a couple of cottages, which provided the access required to build a new housing estate known as Saracen. The third building on the left is the Temperance Hall, built in 1851 it was used for numerous events including, dancing, farmers markets, even as a cinema, but never for the drinking of alcohol.

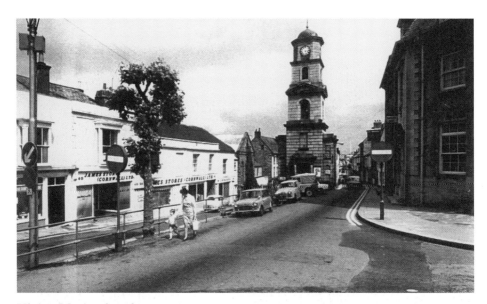

Higher Market Street

Double yellow lines on the right-hand side of the road stop anyone parking their cars and causing an obstruction to the narrow one way system. A mini can be seen in front of an Austin A35 van with a motorcycle parked between. Lower Market Street shows James Store (Cornwall Ltd) who sold furniture, carpets etc. In the late 1890s the Elephant and Castle public house operated under Nicholas Williams. Next along from this is the Temperance Hall. The road into Saracens can be seen clearly in the right bottom corner.

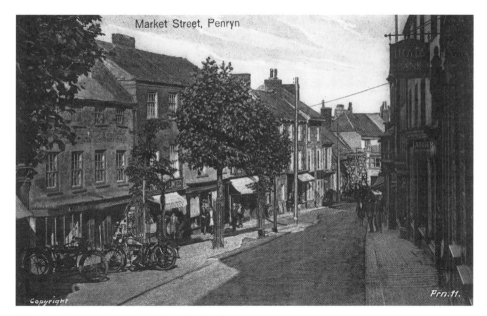

Market Street, alongside Lloyds Bank

This photograph was taken from the other side of the clock tower, outside Lloyds Bank. The trees that can be seen in full bloom were planted in 1902, suggesting that this photograph was taken around 1925. This was a busy part of town at one time, with all of the shops being kept busy. The shops included clothiers (for both men and women), a general store, a chemist, a hairdresser and a butcher. The shop selling Jaeger clothes could have belonged to Miss Ena James, a draper.

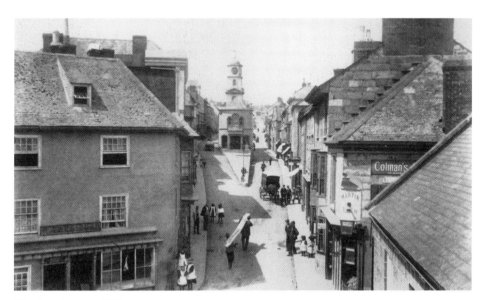

Market Street, 1897

This lovely picture, dated 1897, shows Penryn on a summer's day with a few people out shopping. The premises of Martin & Son the grocer can be seen in the bottom right-hand corner. The Mazawatie tea house stands on the comer of Market Street and New Street. On the opposite side of the road is Robert Tresidder's butcher shop.

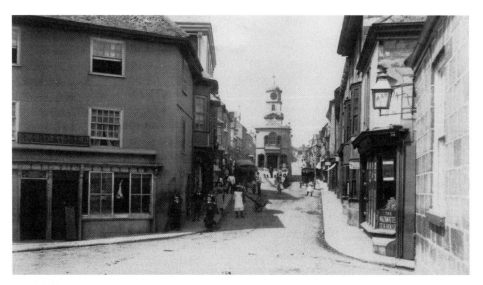

Fish Cross

I feel sure that this photograph was taken at around the same time as the last one. The windows above Tresidders are still open, though seen from a different angle. Reference has been found of two public houses with nearly the same name, half-way up on the right from where the road divides is the Old Golden Lion where Thomas Hellings was the landlord, to the left of the clock tower is the Red Lion, which had the Freemasons emblem carved into the stone above the doorway when William Reynolds was the landlord. The Masons met there only for a few years.

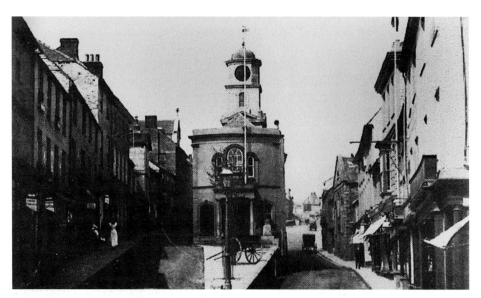

Lower Market Street, Pre-1909

The black face of the clock tower dates this image as being before 1909. Lower Market Street is on the right, the gable-ended building seen in the background is the Temperance Hall; the smaller shops are the drapers, hairdressers and chemists. On the left, with the white lampshades, is Mallets, whose head office was in Truro. A lady can be seen standing outside of Tom Bailey's butchers shop.

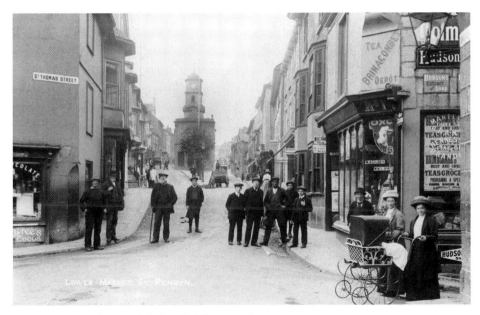

Lower Market Street, joining St Thomas Street

'Fish Cross' is not a name heard of often. It refers to a place many years before this wonderful picture was taken in 1912, formed by a road junction surrounded by a cluster of civic structures at which women would sell fish freshly caught on the day. Brimicomb acquired Martins' shop, which stands on the corner, and began selling groceries as well as wines and Hudsons soap along with other goods. Everyone in this photograph can be seen wearing hats, even the ladies are sporting lovely head gear. But what about that lovely perambulator. It must surely be the Rolls Royce of prams?

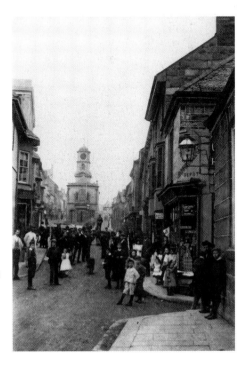

Market House, 1903

I often wonder how the photographer managed to get everyone to stand still to take this picture, taken in 1903. The Market House is prominent in the centre. Money was raised by public subscription to light the four faces of the clock in memory of George Appleby Jenkin, who had been town clerk of the borough for forty-eight years.

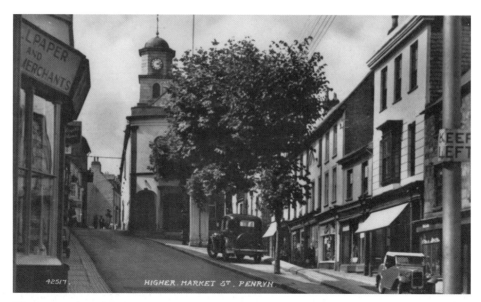

Higher Market Street

The Austin 7 saloon and the Austin 7 convertible parked below the keep left sign date this photograph as being taken around the 1930s, With the trees in full bloom it must have been early summer. On the left-hand side of the photograph, selling wallpaper and merchant's equipment to the people of Penryn, is the hardware store; next door to this is the Penryn Constitutional Club (at which William Ball was Secretary). 'Bilky' Easom, a cycle dealer and repairer, came next, and then Tom Bailey's butcher shop and Lloyds Bank. Seen on Lower Street, with the sun blinds out, is Howard Davies' boot and shoe shop, Alfred Geach's lady and gents outfitters, and Harry Trudgeon's confectionary and bakery.

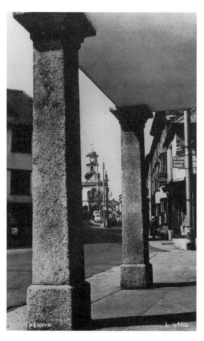

Kings Arms Hotel, Entrance

This photograph is taken looking through the granite pillars that support a canopy and viewing area above the entrance to the Kings Arms hotel it shows the lower side of the Town Hall and clock. The car park sign points to St Thomas Street, which leads to the former location of the old college. Beneath the sign is another street, New Street. On the comer is the Brimicomb grocery shop, which sold Gilbeys Gin, among other things.

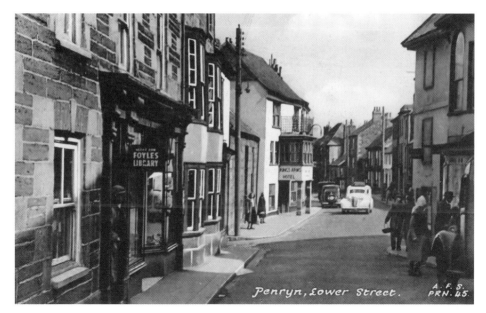

Penryn, Lower Street

This photograph, taken with the Town Hall and clock behind, provides a different view of Market Street looking towards the Kings Arms Hotel and Broad Street leading to the quays and Falmouth. On the left is Fred Chegwidden's stationary shop, seen with a Foyles library sign. Just before the telegraph pole where the pavement curves is New Street and Brimicomb grocers shop, The Kings Arms can be seen further along, recognisable with its distinctive granite pillars.

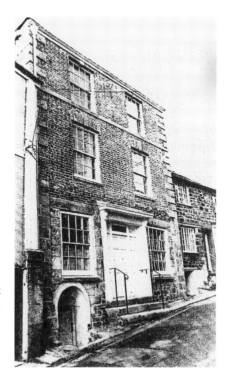

Lady Jane Killigrew's House, St Thomas Street

St Thomas Street is one of the oldest streets in Penryn. This was the old house that Lady Jane Killigrew lived in when she fled from Falmouth in the 1650s having been accused of adultery, piracy and other crimes. Little love was lost between the people of Penryn and the Killigrews, and the mayor gave her his refuge for the next twenty years or so. Following the death of Sir John Killigrew in 1663 Lady Jane returned to Arwenack and donated a solid silver cup and lid (valued then at £12) to the mayor and the residents The cup is now almost priceless, being Penryn's most prized possession. The cup is not kept on show, but does comes out at the mayor-making ceremony.

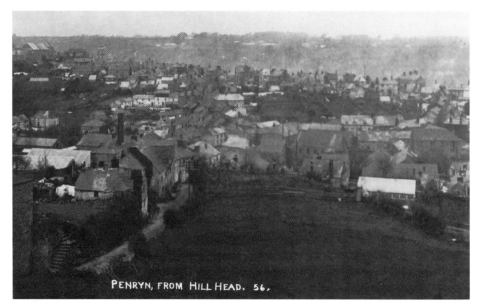

Penryn, from Hill Head

When standing at the bottom of St Thomas Street, cross the road that leads to Glasney on the right and head up the hill towards Constantine. After travelling this way for a quarter of a mile, turn around and you will be greeted by the town clock, which is visible top left comer of picture.

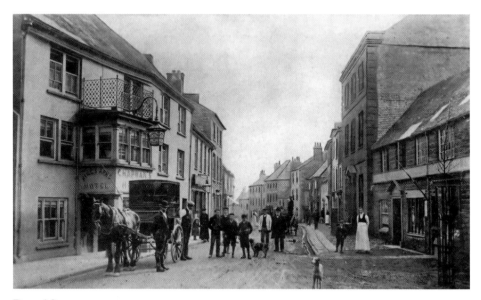

Broad Street

This photograph is taken from 'Fish Cross' and looks across at the road towards Falmouth. It shows Broad Street in around 1905. Outside the Kings Arms hotel stands a horse-drawn carriage waiting to be hired. A sign on the wall of the hotel (above the roof of the carriage) reads 'Chapman's Hotel', as does the lantern above it. From this we can deduce that the landlord was Arthur George Chapman. The man with a white apron standing outside the hairdressers opposite could be Hercules Charles Tregonning.

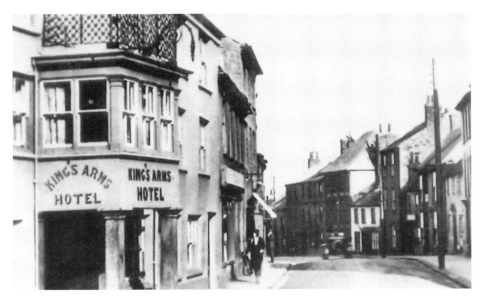

Kings Arms Hotel

This photograph bears the mark of a significant change in our use of roads: it looks like the car travelling out of shot is on the wrong side of the road! The big houses in this street belonged to the owners and captains of ships, mills and other business people. A few changes can be noticed in between this and the previous photograph, the lantern is missing and the name of the hotel on the pillared entrance has changed. Next door to this is John Fumeaux's grocers shop with the sun blinds in use.

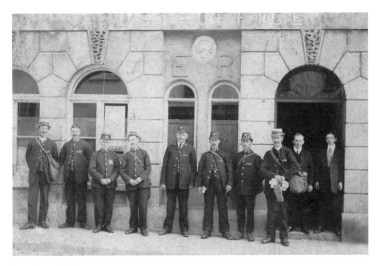

Post Office, Broad Street

1905 saw the opening of the new post office in Broad Street following the closure of its smaller premises further up the road on the left. Eliza Rowe was the post mistress in May 1940 when Roland Hill introduced the penny post (her portrait hangs in the town hall) with salary £72. £18 5s was paid to 'the letter carrier' (postman), including an allowance for conveyance of mail bags from the post office to the mail cart of Messers Rivers & Co. This photograph of 1915 shows the post office staff and eight post men, among them are Bill Tremayne, George Hill and Fred Stevens.

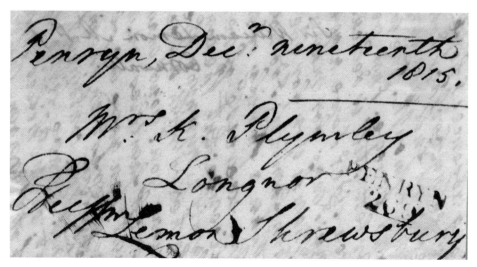

Letter from Penryn to Shrewsbury

Sir William Lemon sent this letter from Penryn 269 to Shrewsbury on 19 December 1815 when he was M.P. for Penryn. After leaving Falmouth for Penryn the route of the mail coach would pass (before the bridge was built) along the riverside and up St Thomas Street; it would stop at Fish Cross to unload and reload before continuing on up the main street and turning down Truro Lane to the Cross Keys public house. I think the coach left Fish Cross by going up the lower side of Market Street, down St Gluvias street and turning left at the bottom where it would continue up Truro Hill to Enys House and Carclew. At the Norway Inn it would receive a change of horses before making its way on to Truro and beyond.

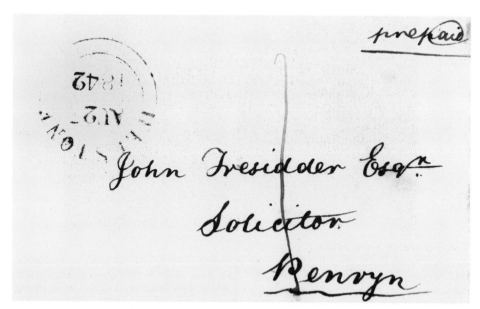

Letter from A. Rogers to John Tressidder

A. Rogers sent this prepaid (top right hand comer) letter on 27 Aug 1842 from Helstone to John Tresidder Esq. Solicitor Penryn. The long line through the address puzzles me, does it mean that the Penryn has been paid.

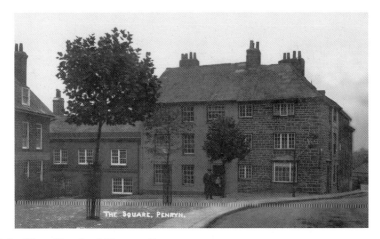

The Night They Bombed Penryn I

At 2.00 a.m. on a cold & rainy morning on the 13 May 1941, a German Heinkel 1/11 air craft thundered over Penryn from the Redruth area being watched and tracked by the Royal Observer Corps at Stithians. With the noise of the siren wailing out an air raid warning, and anti-aircraft guns in the Falmouth-Penryn area trying to shoot the plane down, it must have been deafening. One stick of high explosive bombs was dropped on the blacked out part of the town known as 'the green', next to the square. This area mainly consisted of small town houses built between the fourteenth and fifteenth centuries for professional people like ships' captains, lawyers, other business owners. The photograph shows the square, the houses on the extreme right were the ones destroyed during the raid.

The Square, Penryn, 1920

By 1940, the relatively small houses and cottages of the square were occupied by a variety of ordinary Cornish people. They had gone to bed the evening before the bombing raid not knowing the little town of Penryn would soon be targeted by the Luftwaffe. The bombs fell on a group of houses in the square causing a great deal of damage. Fourteen houses were destroyed with severe damage to other residential properties; additionally, a church hall was destroyed that was once used by the Freemasons of the Borough. All the services – gas, water and telephones – were severely interrupted and the road badly damaged outside at Quay Hill. Bigger houses, which survived the bombing, are seen here on the square around 1920.

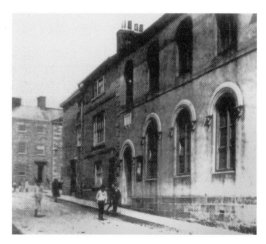

The Night They Bombed Penryn II
The occupants of the houses were sleeping, on hearing the siren a few of the residents took refuge in the nearby air-raid shelter under the green. The Welch family were among them, although their seven-year-old son, Peter, was one of only two that survived; he is still living, now aged eighty-one. He told me that, upon waking, he could

> see the stars and went down stairs crawling along a dark passageway through a huge hole that had been blown into the neighbouring home of Mr & Mrs Allen, they took me to the only house standing at the bottom of Mill Lane, I was collected by my Grandparents the next morning. My Mother severely injured was transferred to a Basingstoke hospital for special treatment, my father went to a local hospital, both came back at a later date.

Above can be seen the smaller houses and Church Institute from around 1920, both were flattened during the raid.

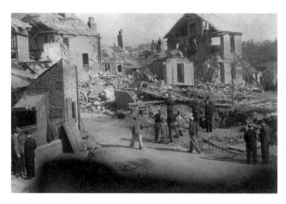

The Green, 1941
Following intensive bombing, most people were trapped or buried in debris. In seconds, members of the home guard, ARP Wardens, demolition squads and fireman arrived on the scene to in rescuing the people working tirelessly even when the anti-aircraft barrage was still in progress. The Penryn WVS and their canteen helped to keep the squads going with food and drink. One family, the Ralph's with one son, were killed as was Mrs Louisa Opie living in the same house. This photograph shows the scene the morning after the bombing and depicts the extent of the damage done.

The Night They Bombed Penryn III

In another house, seventy-eight-year-old Mr John Rapson, his wife and their friends the Tylers from Helston were all killed. Eleswhere, Mr and Mrs Boxhill were dug out with only scratches, though their son David was killed. All of the Pascoe family were wiped out: Percy, Mary, May, Gladys, and two-year-old-Ronald, except for eighteen-year-old Ivor who, now aged ninety-one was buried by rubble for four and a half hours. He later joined the navy in the 1940s. Others who died during the same raid included; Flo Burleigh, Phillipa Pengelly, Florence Hale, Rosemary Pearce. In all eighteen people were killed, ten others were injured seriously and three received minor injuries. The photograph shows the damage done at the bottom of Quay Hill.

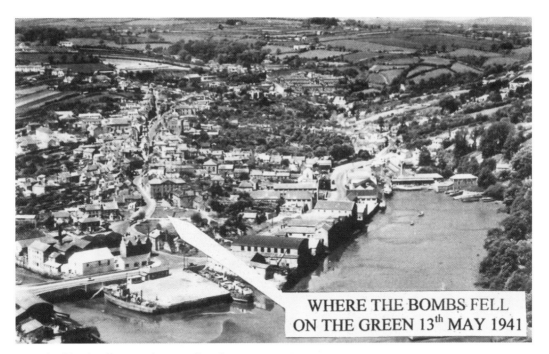

WHERE THE BOMBS FELL
ON THE GREEN 13th MAY 1941

St Gluvias Remembrance Service
Bombing Raid, the Aftermath

Most of the dead were buried at St Gluvias church. Their flower covered coffins were carried by the members of the rescue services between the 15th and 17th May. The processions were watched by the rest of the town who were united in mourning. The services was conducted by Canon Simcock and attended by the mayor, Mr Basher and members of the town council as well as representatives from other local organisations. A garden of remembrance was later created and dedicated five years later, this was again conducted by Canon Simcock. The photograph above shows where the bombs fell on that fatal night.

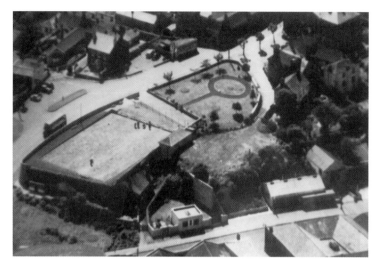

Penryn, Remembrance Garden I

When Revd Perry Gore came to St Gluvias church in 1959 he was very keen on getting a new church hall to replace the one that had been destroyed. An appeal was made, and soon Mrs Dourman gave the church a house with a large garden in West Street. All sorts of activities including concerts were held to raise the £7000 needed to build the hall. Mr Barnicoat of Mylor obtained the contract and, with money from the War Damages Commission and a final donation from Mrs Rouse of £600 to clear the final amount. The picture above shows an aerial view of the bowling green and remembrance gardens.

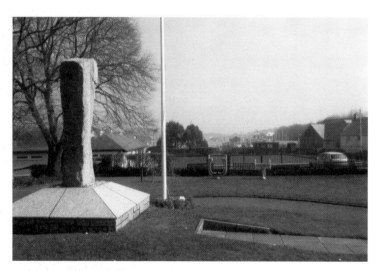

Penryn, Remembrance Garden II

In the centre of this remembrance garden stand two granite plinths that symbolise the granite port of Penryn. At the bottom of the flagpole is a large bronze plaque that reads 'Borough of Penryn'. The plaque was unveiled by Mrs F. Lobb, who lost some of her family in the bombing raids. These gardens have been provided to remind all those who see them that houses once stood on the site which were destroyed during an evening raid in the early morning on 13 May 1941 when eighteen lives were lost. This photograph looks down past the bowling green towards Falmouth from the gardens.

CHAPTER TWO

Servicemen in the First World War & World War Two

Tom Woolcock
On the right is First World War serviceman
Tom Woolcock of the 7th Battalion Duke of
Cornwall Light Infantry, seen here with his three
year stripe.

William Pellow
Seen here is William Bellow, judging by his attire it is likely that he was a bugler, as he relaxes with a cigarette.

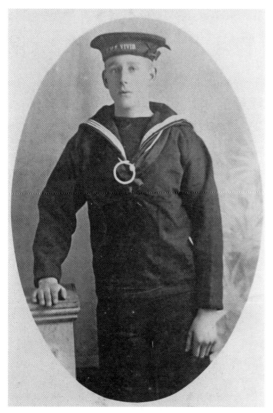

Charles Welch
On the left can be seen Charles Welch, a stoker aboard HMS *Indefatigable*. He was drowned in the First World War when his ship was sunk during the Battle of Jutland.

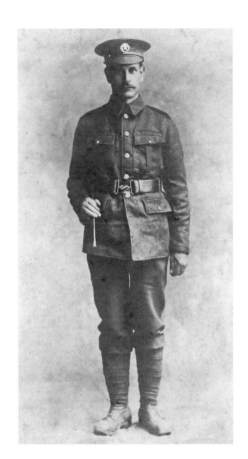

Thomas Pearce

The portrait on the right shows Thomas Pearce a
soldier in the Duke of Cornwalls Light Infantry. He
was killed in action at Arras, France, in April 1917
aged thirty-four.

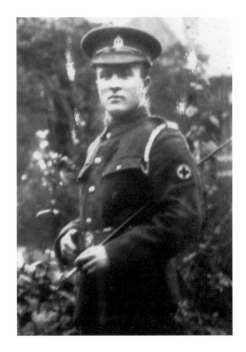

Fred Brewer

Fred Brewer (who sent the card [overleaf] to his
girlfriend) is seen in the photograph on the right.
He was captured in 1918 when he was a private in
the Royal Army Medical Corp.

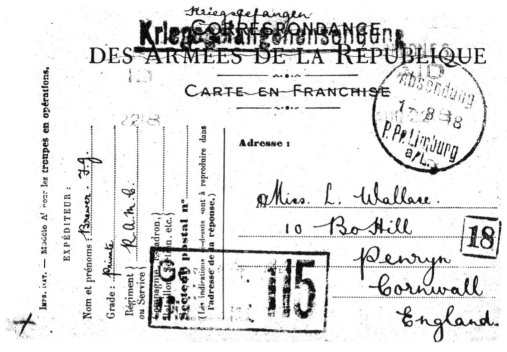

Postcard to Lily Wallace

This card (above and below) was sent from Germany to Lily Wallace of Bow Hill on 24 June 1918. It received its official stamp several weeks later on 1 August 1918. I hope she received it before Christmas after it had been censored. Written in a lovely cursive script, the last sentence is rather poignant.

Kriegsgefangen

Cette carte doit être remise au vaguemestre. Elle ne doit porter aucune indication du lieu d'envoi ni aucun renseignement sur les opérations militaires passées ou futures.

S'il en était autrement, elle ne serait pas transmise.

PARTIE RÉSERVÉE À LA CORRESPONDANCE. 24 - 6 - 18

Dear Liley

A few lines to say I am quite well and very pleased that I can write to you. I only wish I could get a line from you, you can bet I will send the address the first chance I get. I still have all your photos. I hope you are enjoying your selves, beaching and pasties? how nice! I fancy my chances to seeing those times again. Remember me to my Aunt, Aleck & all of them at home. also all I know. You have got a rest from writing at last, worse luck for me, anyhow cheer up. give my kind regards to Lythia and your father and accept my fondest love for yourself from Yours always ×××××× F.J. Brewer. I might be are being well treated. and I have plenty of pals. 24-6-18

for all were caught,

42

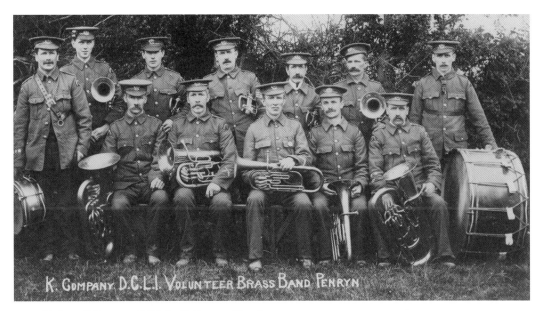

Duke of Cornwall Light Infantry Band
This Duke of Cornwall Light Infantry band would attend most parades and marches in the area. They practised in Penryn's Drill Hall in New Street around 1920.

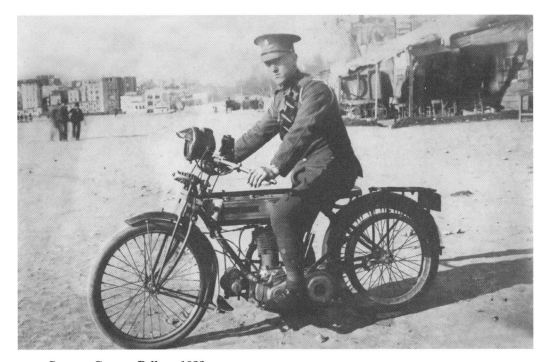

Gunner George Pellow, 1923
Above can be seen Gunner George Pellow Army No. 2202770 D.C.L.I. This photograph was taken in 1923 at Roe-De-Pera Constantinople. The motorcycle is a belt-driven Royal Enfield, Note the shield on the head lamp.

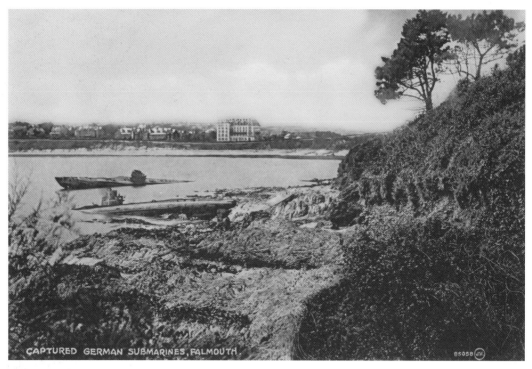

Captured German Submarines I
With Falmouth Hotel in the background, it can be deduced that these German submarines were captured and brought up on the rocks to be dismantled near Castle Point around 1925.

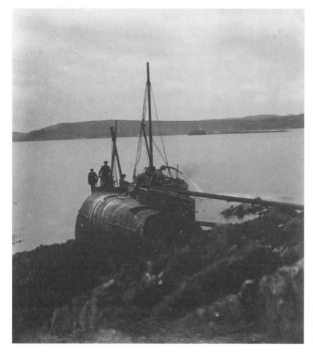

Captured German Submarines II
Left can be seen (taken later) that a start has been made to cut up and dismantle the submarines.

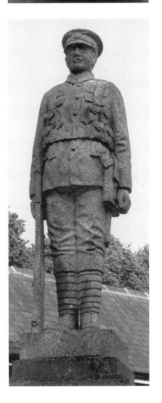

Granite Soldier War Memorial

This granite War Memorial in a tiny garden at the comer between Savage Lane and Vicarage Lane in Dore, Sheffield. It depicts a soldier standing to attention with his rifle grounded. It was made from drawings by Edward Spargo who owned Trevone Granite Quarry at Mabe near Penryn. A full-size lathe and plaster model was made, as can be seen damp has rotted away the feet and leg to the knee. It took the sculptor, William Frances, between eighteen months and two years to carve the soldier at Tin-Pit shed. Cornish granite workers are incredibly skilful stone cutters and the statue is made of the finest grain granite upon which one wrong move or hit could potentially destroy hours of work. The monument was unveiled in 1920 and placed on a fine sandstone pedestal attached to which are bronze panels from the First World War, including the names of two women, later another plaque was added to commemorate the Second World War.

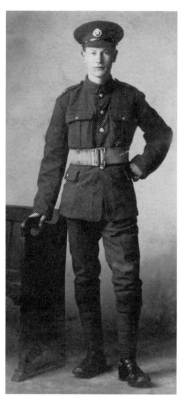

Willie Collins

Left can be seen a man believed to be Willie Collins of the Duke of Cornwall Light Infantry.

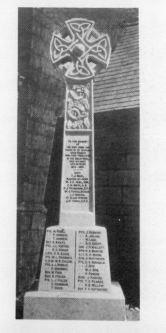

ST. GLUVIAS & PENRYN WAR MEMORIAL.

Penryn Granite War Memorial

Left can be seen the Penryn granite War Memorial at St Gluvias Church. It is in memory of the men from the parish of St Gluvias who gave their lives in the Great War that we might live in peace. The memorial has been engraved with a long list of brave men never to return to the Borough Army and Navy (the Air Force was in its infancy).

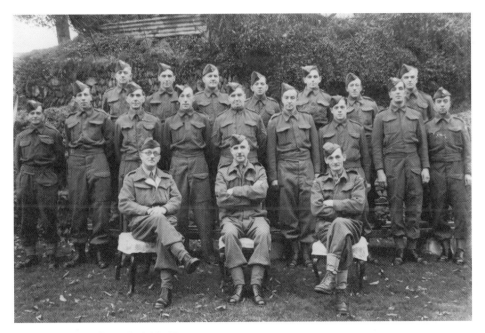

Penryn Home Guard 1944–45

This group of hard working men busied themselves with their respective jobs during the day, then would go out at night together to help to defend the country under the command of Capt. Marchell, Major Davies, and Norman Dale (seen sitting). These local defence volunteers were, back row left to right: Edward Warmington (my father), Tom McCabe, William James, Richard Ivey, D Chamberland, Ernie Mallet, Leslie Buckingham. Middle row: B. Blear, Reggie Toy, B Carter, L Penver, Corp. Bill Andrew, Jimmy Newman, George Wallace, C. Young, B. Blee.

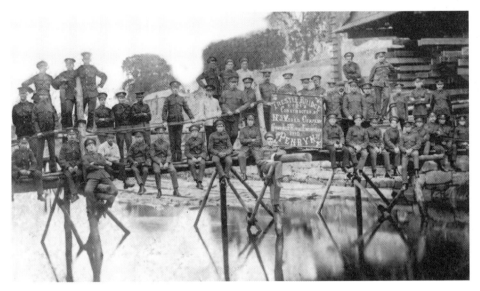

Trestle Bridge Building Competition

A trestle bridge building competition held by No. 3 Works Company Cornwall Royal Engineers in Penryn in 1910.

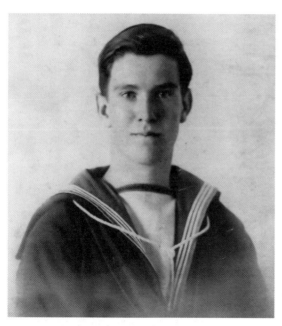

Alfred John Stumbles
On the left can be seen a photograph of
Alfred John Stumbles, Royal Navy stoker.

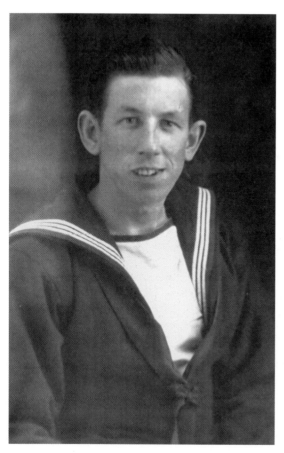

George Foulks
George Foulks served in the Royal Navy
as a stoker and was the landlord of the
Seven Stars in Penryn with his wife Peggy
for years.

Penryn Town Council I
Members of Penryn Town Council are seen above, together with the WVS being shown how to bake pasties on a wood-burning stove at Trelawney Park The gentleman on the extreme right is Cllr Mark Tallack, one time mayor of the town.

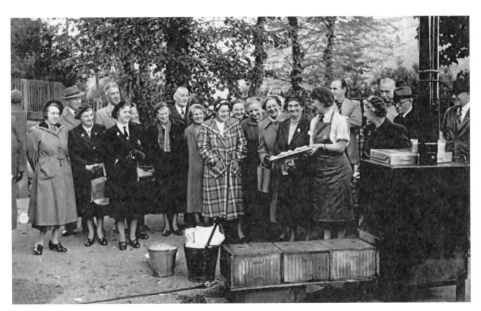

Penryn Town Council II
Similar to the previous picture, this photograph shows members of the Penryn Town Council on what must have been cold weather with most ladies wearing hats and a few men as well, both pictures were taken during the Second World War.

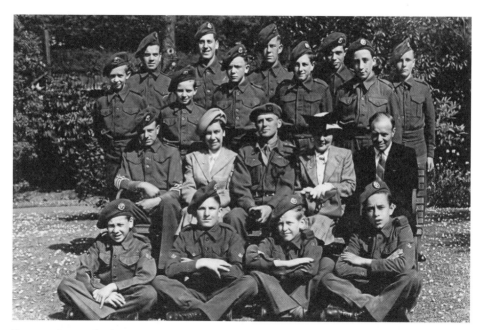

Penryn Army Cadets 1950s
Back row: Joe Hendra, Dave Reynolds, Ken Trevaskis, - Rundle. Second row: Phillip Lane, Billy Symons, Pinky Read, Maurice Fuller, D. Tregenza. Seated: Teddy Ford, unknown, Bill Sowden, unknown, unknown. Sitting on the grass are: unknown, Lyman Rickard, Douglas Pellow, Harry Wilkes.

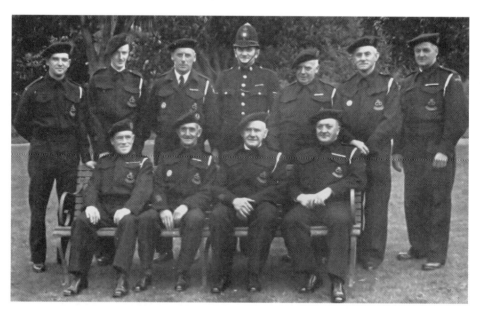

Penryn Air Raid Precautions Wardens
The above photograph shows the Penryn Air Raid Precautions Wardens. Seen standing are: C. Lobb, unknown, P. T. Dancer (Head Warden) P. C. Bullock, T. G. Gill, Oscar Ball, J. Hosking. Sitting: G. Manning, C. H. Chegwidden, W. C. Basher, H. C. Thomas.

Dedication of a New Motor Vehicle Ambulance

A photograph of the the vehicle mentioned to the right dedication eludes me. The dedication service was conducted by Revd Canon H. R. Jennings MA, assisted by Revd H. C. F. Cory of Penryn. The ambulance was named by Miss C. Truscott after being unveiled by R.J. Roddis Esq, and acceptance made on behalf of the Penryn Division by Supt. J. H. Tressidder. A vote of thanks was proposed by J. R. Edwards and seconded by H. G. Probert.

The St. John Ambulance Brigade
PENRYN DIVISION

Order of Service
ON THE OCCASION OF

The Dedication of the
New Motor Ambulance

" ST. MARY "

At the TOWN CENTRE, PENRYN
(If wet, "Wesley" Methodist Church)

On Sunday, November 7th, 1943

At 3.30 p.m.

Organist:—Ald. P. T. DANCER, J.P., Vice-President

J. H. LAKE & Co., Ltd., FALMOUTH

DEDICATION SERVICE.

Conducted by the Reverend Canon H. R. JENNINGS, M.A.,
of Truro.

Assisted by the Rev. H. C. F. Cory, Penryn.

HYMN (No. 368 A. and M.)

THOU to Whom the sick and
 dying
Ever came, nor came in vain,
Still with healing word replying
To the wearied cry of pain.
 Hear us, Jesu, as we meet
 Suppliants at Thy mercy-seat.

Still the weary, sick and dying
Need a brother's, sister's care,
On Thy higher help relying
May we now their burden share,
Bringing all our offerings meet
Suppliants at Thy mercy-seat.

May each child of Thine be willing,
 Willing both in hand and heart,
All the law of love fulfilling,
 Ever comfort to impart ;
 Ever bringing offerings meet
 Suppliant to Thy mercy-seat.

So may sickness, sin and sadness
 To Thy healing virtue yield,
Till the sick and sad, in gladness
 Rescued, ransom'd, cleansed,
 heal'd
 One in Thee together meet,
 Pardon'd at Thy judgment-seat

PRAYERS.

For the King, Ministers of the Crown, and those who administer.

ALMIGHTY God, the foundation of all goodness, we humbly beseech Thee to bless our Sovereign Lord King George, the Sovereign Head and Patron of the Order, the Ministers of the Crown, the members of the several Parliaments in all his Dominions and all who are set in authority under him : that they may order all things in wisdom and justice, righteousness and peace, to the honour of Thy Holy Name, and the good of Thy Church and people ; through Jesus Christ our Lord. Amen.

For the Peace of the World.

ALMIGHTY God, from whom all thoughts of truth and peace proceed ; Kindle, we pray Thee, in the hearts of all men the true love of peace, and guide with Thy pure and peaceful wisdom those who take council for the nations of the earth ; that in tranquility Thy kingdom may go forward, till the earth is filled with the knowledge of Thy love ; through Jesus Christ our Lord. Amen.

For all who are afflicted.

ALMIGHTY God, who art afflicted in the afflictions of Thy people and art full of compassion and tender mercy, hear us as we pray for those who are passing through hard times, those whose livelihood is insecure and who cannot find work ; those who have lost the health and strength that once was theirs and who are trying to face illness and suffering bravely ; for those who lie in pain and have to face undergoing operations ; for those who have

to bear their burdens alone and are victims of depression and fear. All these we commend to Thy tender care and love ; through Jesus Christ our Lord. Amen.

For all who wear the White Eight Pointed Cross.

LET us pray God, through Jesus Christ our Lord, that as we wear the sign of our Redemption, so we may ever remember in our lives that its four arms symbolise the Christian Virtues— Prudence, Temperance, Justice and Fortitude ; that its points represent the eight Beatitudes which spring from the practice of those virtues ; and that its whiteness is the emblem of that purity of life required in those who fight for the defence of the Christian Faith and live for the service of the poor and suffering. Amen.

For the sick and all who minister to them.

ALMIGHTY God, whose Blessed Son Jesus Christ, went about doing good, and healing all manner of sickness and all manner of disease among the people ; continue, we beseech Thee this His gracious work among us, especially through the St. John Ambulance Brigade and in the Hospitals and Infirmaries of our land ; cheer, heal and sanctify the sick ; grant to the physicians, surgeons and nurses wisdom and skill, sympathy and patience ; and send down Thy blessing on all who labour to prevent suffering and to forward Thy purpose of love ; through Jesus Christ our Lord. Amen.

HYMN (Tune Austria).

Dedicated to the St. John Ambulance Brigade.

HOLY Father, King Eternal,
 Jesu, God's Incarnate Son,
With the Ever-Blessed Spirit,
 One in Three, and Three in One,
Praise and honour, love and service,
 Lord we humbly bring to-day :
Grant to us Thy help and guidance,
 May we learn from Thee alway.

Thou O Great Physician Wondrous,
 Fill our hearts with love for Thee;
May we strive for one another,
 Thy true followers ever be.
Crown our efforts with Thy Blessing,
 So we shall not strive in vain,
Thou our actions ever guiding,
 May we succour, save from pain !

Bind our hearts in hallow'd union,
 As true soldiers may we stand ;
Led by Thee, our Heavenly Captain,
 Onward to the Fearless Land.
Strong and faithful, gentle, loving,
 Blessed Jesu, we would be,
Banded in Communion, Holy,
 Consecrated, Christ to Thee.

Holy Father, God Eternal,
 Bless and keep us Thine indeed.
O renew us with Thy favour,
 Thou who knowest every need
Honour, Glory, Might and Power,
 Unto Thee for ever be.
Adoration, Love and Service,
 Humbly we present to Thee.

Naming of the Ambulance by Miss C. Truscott.

Unveiling and presentation of Ambulance by R. J. Roddis, Esq. (President) to the County Commissioner, Lieut.-Colonel W. Blackwood, D.S.O., Commander of the Order; acceptance on behalf of the Penryn Division by Supt. J. H. Tresidder.

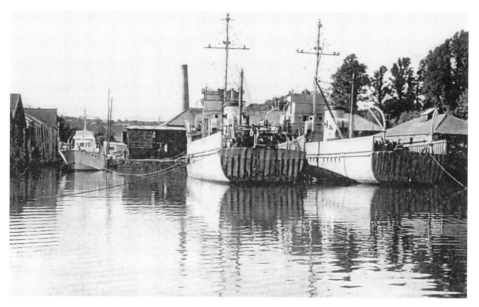

Motor Torpedo Boat
Above is a close up photograph of motor torpedo boats, taken at the head of the Penryn River.

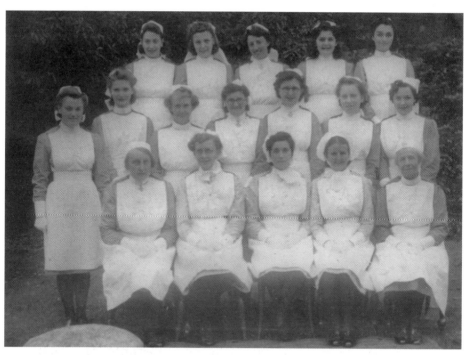

Members of the Penryn St John's Ambulance
The wonderful ladies of the Penryn St John's Ambulance. Back row: Inez Wills, Mrs Cox, Mrs Daniels, unknown, Verney Davies. Middle row: Betty Brewer, Darcie Stumbles, Mrs Mallet, Mrs Buckingham, Nancy Kneebone, Una Dawn, Ulga King. Front row: Miss F. Butland, unknown, Mrs Blank, Joan Nicholls, unknown.

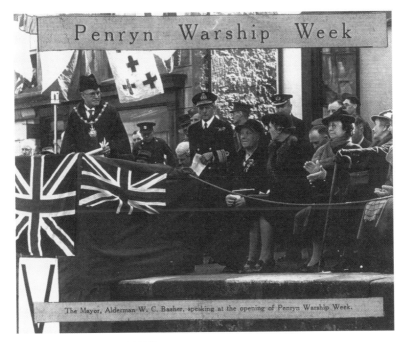

The Mayor, Alderman W. C. Basher, speaking at the opening of Penryn Warship Week.

Penryn Warship Week *c*. 1941/42
The Mayor Alderman, W. C. Basher, can be seen above outside the Seven Stars public house at the opening of Penryn's Warship Week. With flags and bunting flying there is plenty of gold braid on show with the naval men.

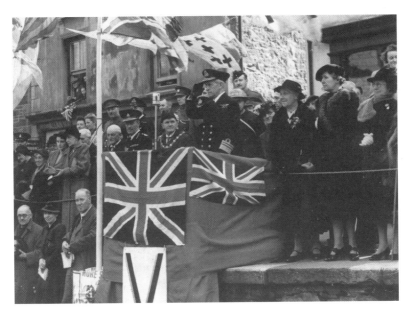

Alderman Basher and Naval Officers
With a 'V for victory' sign seen displayed proudly in the centre of the image, this is clearly a moral boosting venture. This photograph shows again Alderman Basher (standing between the naval officers) wearing his chain of office. To the left of the photograph is Allen May's sweet shop.

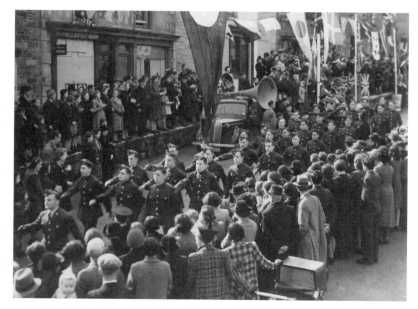

Penryn Air Training Corps 115 Squadron on the March
The parade has moved on in this photograph, past Alan May's sweet shop. Here the Penryn Air Training Corps 115 Squadron and Co. can be seen proudly marching through the crowded main street, during Warship Week, with appropriate music blasting out.

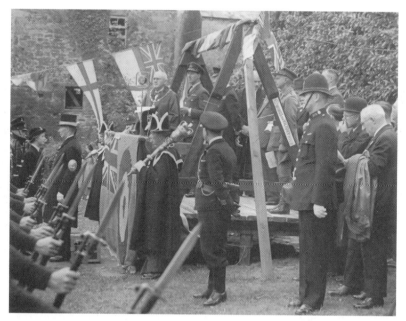

Wings for Victory Week I
The people of Penryn celebrating Wings for Victory Week. Mayor Basher can be seen again taking the salute, with help from the air force. It looks like half the corporation has turned out to give support to the town crier and two mace-bearer's including the Dutch Navy with drawn bayonets and a policeman.

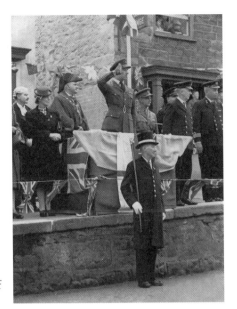

Wings for Victory Week II

The mayor can be seen here again taking the salute during the Wings for Victory Week, this time outside the Seven Stars in Penryn's main street. Mayor Basher is wearing his regalia with his town clerk behind him and the town crier in front is supported by members of the Dutch Navy from Enys around 1940.

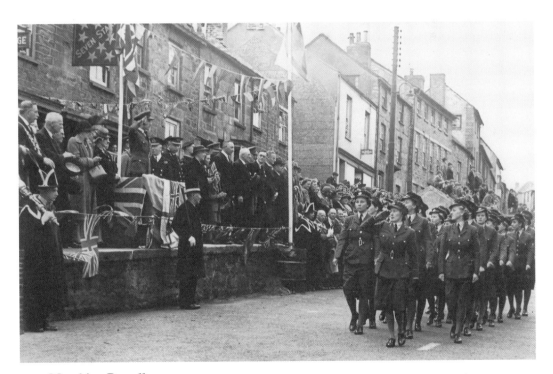

Marching Proudly

These women of the Woman's Air Force can be seen taking the salute from a superior officer. In this photograph the mayor stands in the background, in the foreground are the mace-bearers and the town crier. The window that can be seen in the gable-end of the house that is next door to the shop with the telephone sign was once my bedroom window. As a youngster I could see the town clock and was never late for school (which was next door). Outside the front of the house with the boys on the roof were full tanks of water to use in case of a fire.

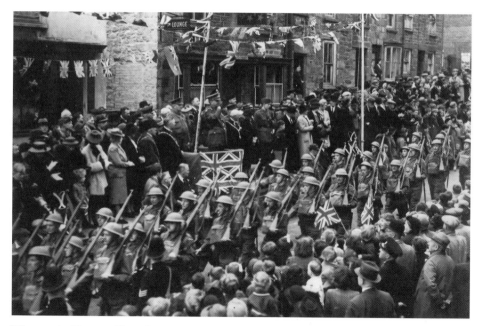

Victory in Europe Parade

This photograph seems to show what looks like three mayors (Penryn, Falmouth and perhaps Helston) overseeing the Victory in Europe parade in 1945. Soldiers of the Duke of Cornwall Light Infantry proudly march through the streets of Penryn. That evening a bonfire was started in the road outside the Seven Stars, a piano was pulled out from an empty house and burnt. I know this as I helped the sailors from a ship in Falmouth to do it. There is one lady who can verify this, she lived opposite with her family and still lives in the town today.

TULLIMAAR
PERRANARWORTHAL
CORNWALL
GREAT BRITAIN

Inscribed for you by Princess Martha Bibesco

IN THIS HOUSE GENERAL EISENHOWER, SUPREME COMMANDER OF THE ALLIED FORCES, DWELT FOR A FORTNIGHT BEFORE D DAY IN MAY 1944

General Eisenhower Was Here

A scanned certificate of dwelling that was presented to the owner of the premises following General Eisenhower's, Supreme Commander of Allied Forces, stay in the lead-up to D Day.

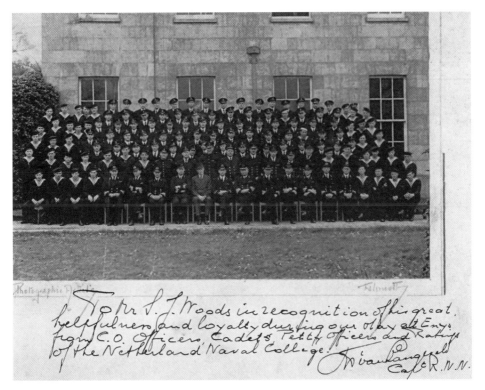

Dutch Naval College I

The Dutch Navy took over the Enys Estate from the beginning of the Second World War around 1940. This photograph was taken and presented to Sidney Woods, who owned a taxi business in West Street, and signed by the Dutch captain.

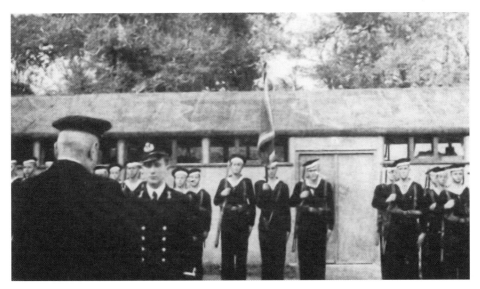

Dutch Naval Company

The photograph above shows part of the Dutch Naval Company on display.

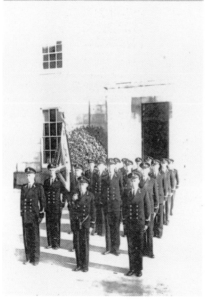

Dutch Naval College II

The Dutch Navy stayed at Enys house for only six years as the picture says 1940–46. The company officers can be seen here on parade with their national flag.

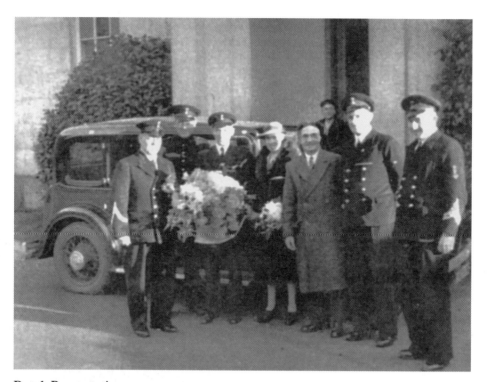

Dutch Presentation

When the Dutch Navy left they presented Sidney Woods and his wife with the large company photograph and a bouquet of flowers. Sidney Woods was always available to go anywhere at a moments notice with his large Austin automobile, he went all over Cornwall taking the Dutch Commander where he wanted to go day or night.

1. HIS WORSHIP THE MAYOR will speak.

2. HYMN "All people that on earth do dwell."

ALL people that on earth do dwell,
 Sing to the Lord with cheerful voice :
Him serve with fear, His praise forth tell ;
 Come ye before Him and rejoice.

The Lord, ye know, is God indeed ;
 Without our aid He did us make :
We are His flock, He doth us feed ;
 And for His sheep He doth us take.

O enter then His gates with praise ;
 Approach with joy His courts unto ;
Praise, laud, and bless His name always,
 For it is seemly so to do.

For why ? The Lord our God is good ;
 His mercy is for ever sure ;
His truth at all times firmly stood,
 And shall from age to age endure. ~~Amen~~

To Father, Son and Holy Ghost,
 The God Whom Heav'n and earth adore,
From men and from the Angel-host
 Be praise and glory ever more.

3. PRAYER - - Rev. C. H. F. CORY.

4. HYMN - "Now thank we all our God."

NOW thank we all our God,
 With hearts, and hands, and voices ;
Who wondrous things hath done,
 In whom His world rejoices ;
Who, from our mothers' arms,
 Hath blessed us on our way
With countless gifts of love,
 And still is ours to-day.

O may this bounteous God
 Through all our life be near us,
With ever-joyful hearts
 And blessed peace to cheer us,
And keep us in His grace,
 And guide us when perplexed,
And free us from all ills
 In this world and the next.

All praise and thanks to God
 The Father now be given,
The Son, and Him who reigns
 With them in highest heaven :
The one, eternal God,
 Whom earth and heaven adore ;
For thus it was, is now,
 And shall be evermore. Amen.

5. A READING FROM THE BIBLE.

L. G. HONEY (Corps Sgt. Major S.A.).

6. HYMN "Praise my soul, the King of heaven."

PRAISE, my soul, the King of heaven,
 To His feet thy tribute bring ;
Ransomed, healed, restored, forgiven,
 Evermore His praises sing ?
 Praise Him ! Praise Him !
 Praise the everlasting King.

Praise Him for His grace and favour
 To our fathers in distress ;
Praise Him, still the same for ever,
 Slow to chide and swift to bless :
 Praise Him ! Praise Him !
 Glorious in His faithfulness.

Father-like He tends and spares us ;
 Well our feeble frame He knows ;
In His hands He gently bears us,
 Rescues us from all our foes :
 Praise Him ! Praise Him !
 Widely as His mercy flows.

Thanksgiving Service

The borough of Penryn held a thanksgiving service to mark the end of the war in Germany. The mayor began this with a speech that was followed by a hymn and a sermon delivered by Revd C. H. Cory. After a further hymn and Bible reading by the Salvation Army Corps Major Leslie Honey an additional hymn was sung followed by an address by Revd J. A. Sincock. A final hymn preceded a concluding prayer (read by Mr W. L. Knight). The service was ended with a rousing rendition of the National Anthem.

Angels help us to adore Him ;
 Ye behold Him face to face ;
Sun and moon, bow down before Him ;
 Dwellers all in time and space,
 Praise Him ! Praise Him !
 Praise with us the God of grace. Amen.

7. AN ADDRESS - Rev. J. A. SIMCOCK.

8. HYMN "Eternal Father, strong to save."

ETERNAL Father, strong to save,
Whose arm doth bind the restless wave,
Who bidd'st the mighty ocean deep
Its own appointed limits keep :
 O hear us when we cry to Thee
 For those in peril on the sea !

O Saviour, whose almighty word
The winds and waves submissive heard,
Who walkedst on the foaming deep,
And calm amid its rage didst sleep :
 O hear us when we cry to Thee
 For those in peril on the sea !

O Sacred Spirit, who didst brood
Upon the chaos dark and rude,
Who bad'st its angry tumult cease,
And gavest light, and life, and peace :
 O hear us when we cry to Thee
 For those in peril on the sea !

O Trinity of love and power,
Our brethren shield in danger's hour ;
From rock and tempest, fire and foe,
Protect them wheresoe'er they go ;
 And ever let there rise to Thee
 Glad hymns of praise from land and sea.

9. CONCLUDING PRAYER - - - -

Mr. W. L. KNIGHT.

10. NATIONAL ANTHEM.

T. MARTIN, PRINTER, PENRYN.

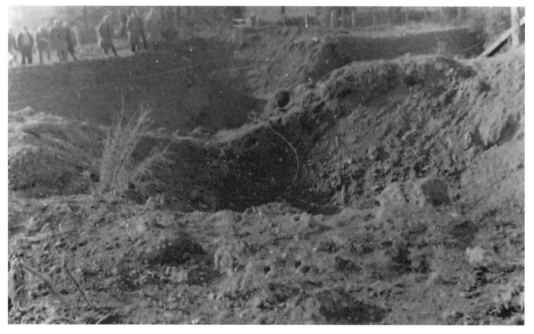

Parchute Mine Crater

Earlier you read of how I saw a parachute mine fall near St Gluvias Church during an air raid on Penryn. While this did not explode, it did leave a large crater, as this photograph demonstrates.

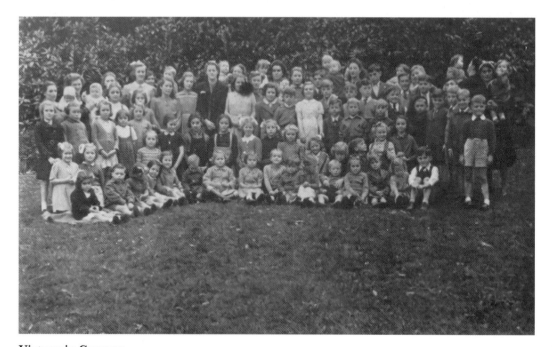

Victory in German

A group of Penryn children as they celebrate victory in the Second World War. The photograph was taken at Trelawney Park around 1945/46.

CHAPTER THREE

Trains & Transport

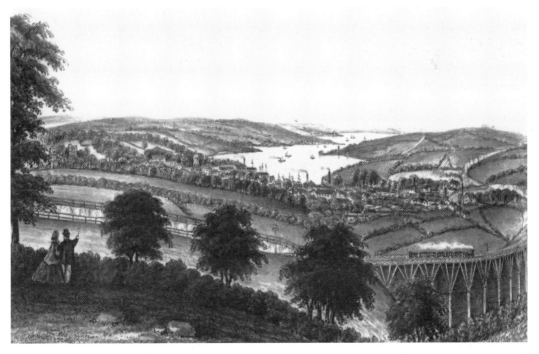

Brunel's Wooden Viaduct
Above is a drawing of Isambard Kingdom Brunel's wooden viaduct that crosses the valley at Penryn on the Falmouth to Truro route. Penryn's industrial works can be seen in the foreground and Falmouth and the harbour in the background.

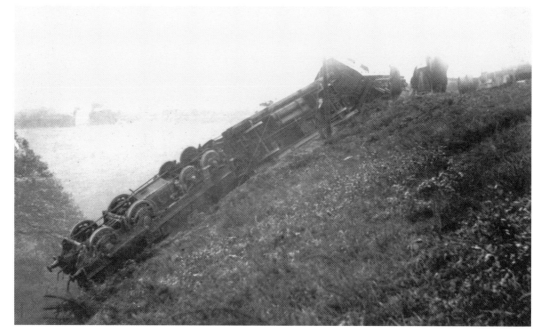

Engine Derailed, 1898 I

In October 1898 a mail train with passengers became derailed on a fast bend near Penryn, coming to rest with the engine's funnel imbedded in the slope. Mr Cotterill, the driver, died in hospital. The picture above shows the engine on its back with workmen around it.

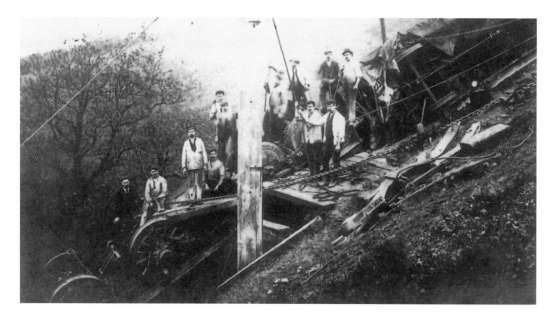

Engine Derailed, 1898 II

The picture above shows the recovery of the engine. As can be seen the engine is in pieces, though the mail was recovered intact. One of the firemen that was called out caught pneumonia and died, two gentlemen passengers emerged with their top hats like concertinas.

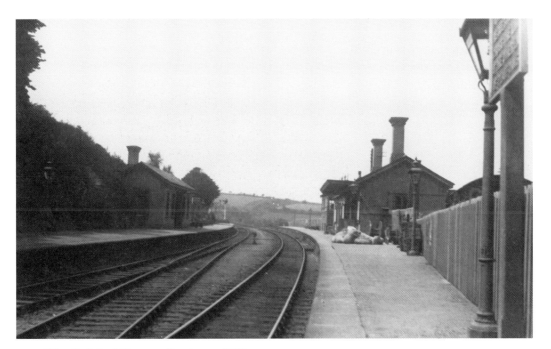

The Original Penryn Station *c.* **1920**

When the branch line was built in the 1860s from Truro to Falmouth, the railway track formed a giant 'S' through the station with no straight track at all. In this photograph the rail is outside the waiting room, also showing the up-line and signal.

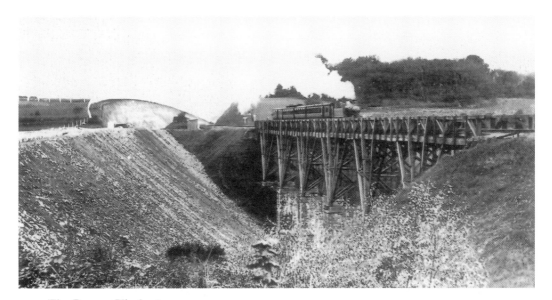

The Pascoe Viaduct

A major reconstruction scheme was implemented in the 1920s which meant removing thousands of tons of earth to create straighter tracks. Here we see an engine and carriages steaming across the old wooden bridge on the Truro side of Penryn station. The Pascoe Viaduct was later removed, though some stone pillars still remain and can be seen at the rear of Harbour View.

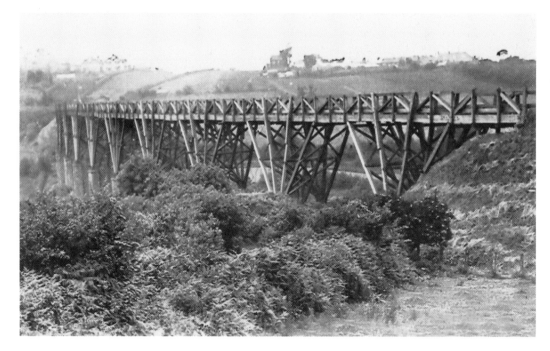

College Woods Viaduct I

This photograph, which looks like it came from a Box Brownie, shows the original wooden viaduct. Built on a curve over College Woods, the viaduct was designed and built by Brunel and was the last on the branch line.

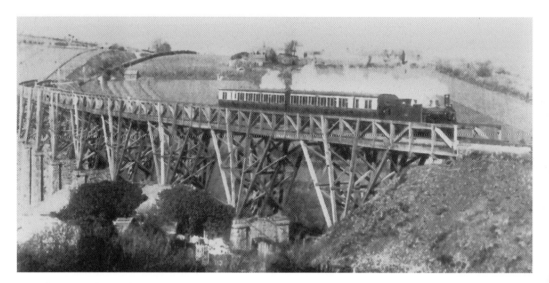

The College Woods Viaduct II

The engine and carriages above is passing over the same area as in the previous photograph on its journey to Falmouth. An elderly lady once told me she would close her eyes and pray every time the train went over the rickety wooden bridge. It was known that the sparks from the engine had set fire to it a few times before.

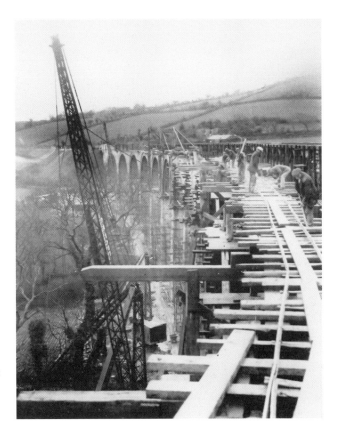

Building the New Bridge
Because of the need for constant repair, the powers that be decided to replace the wooden bridge with a stone one. This photograph shows the carpenters working on the new bridge alongside the old wooden one, with a huge crane on the left and a smaller one beneath to help with lifting heavy parts in the 1930s.

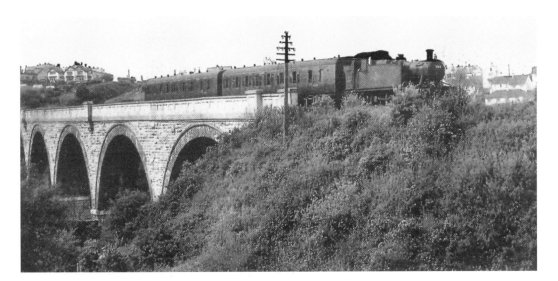

Engine Passing Over the New Bridge
A train approaching Penryn station from the Falmouth direction around 1955. The finished bridge can also be seen, it was 946 feet long and stood 102 feet above College Woods and took approximately four years to build. I am reliably informed that the engine seen here is a Truro-based 4575 class 2-6-2Ts, No. 5562.

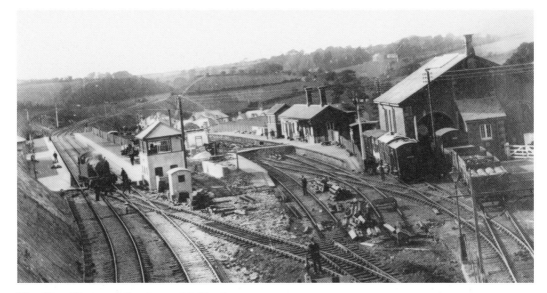

The New Line and Station, with Engine
The new layout at Penryn station from around the 1950s. As can be seen, the rails no longer pass in front of the building with two chimneys (see top of page 63) that held the waiting room and ticket office. The space that has been saved is being used as a marshalling yard, with a locomotive passing over from the up to down lines, alongside the signal box.

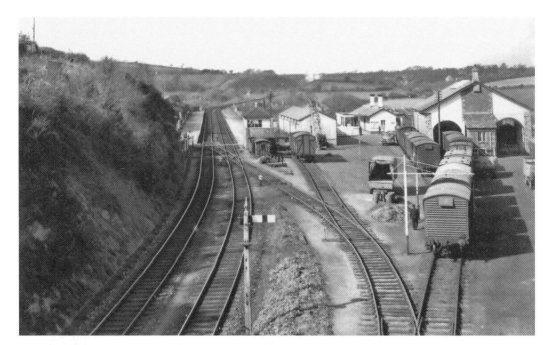

New Line Signal and Goods Wagon, *c.* 1950s
Similar to the view above, another view of the marshalling yard showing a goods wagon being moved in and out of the dry storage sheds to load or unload the goods. It must have been a lovely day, look at the shadows of the goods wagons.

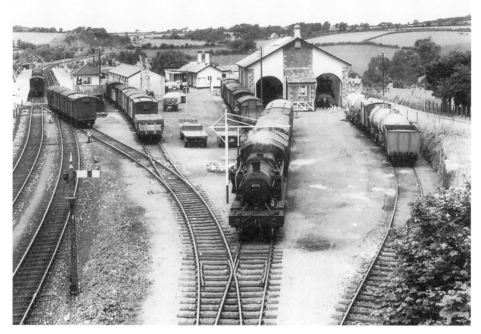

Penryn New Station, Engine No. 4574, *c.* 1950s

Engine No. 4574 and its driver about to climb aboard it, with an atmospheric wisp of smoke spouting from the train. Perhaps he is going to move the four wagons from where they stand alongside the signal box and off the down line. A train can also be seen waiting to leave Penryn for Perranwell and Truro.

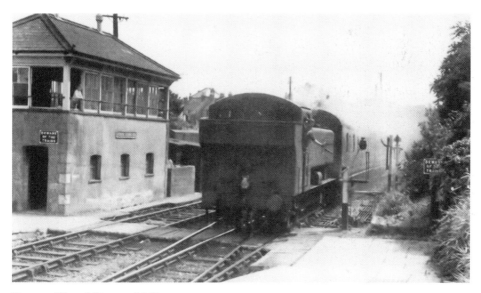

Penryn Signal Box, *c.* 1960

A train entering Penryn station where a fireman can be seen exchanging the single line token on the post by the engine.

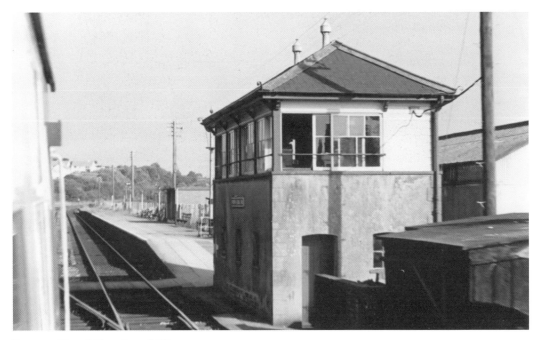

Penryn Signal Box, late 1950s

Penryn signal box alongside the down-line to Falmouth in the late 1950s. At this time, Arthur Pomeroy was station master and Victor Williams was the signalman.

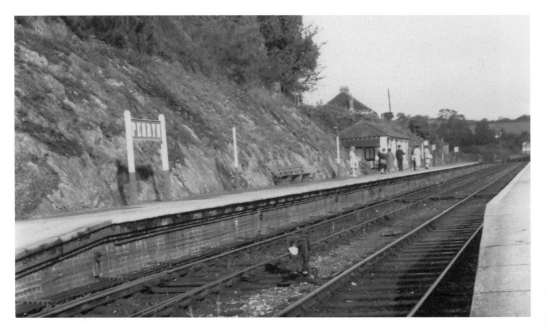

Penryn Up-Line, *c.* 1950s

It looks like there are passengers waiting for the train to Truro with some time before the signal drops. I can tell you that, at about the same time, after being at sea for nearly twelve months, it was a wonderful sight looking down that river towards Falmouth knowing that you were home on leave.

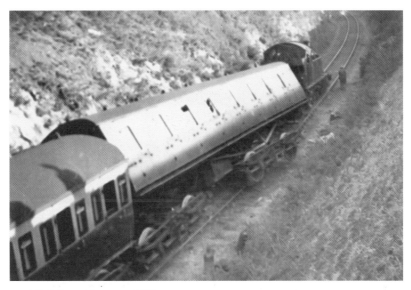

Penmere Halt Derailment, 1941
This carriage became derailed, possibly as a result of an air raid, near to Penrmere Halt in January 1941.

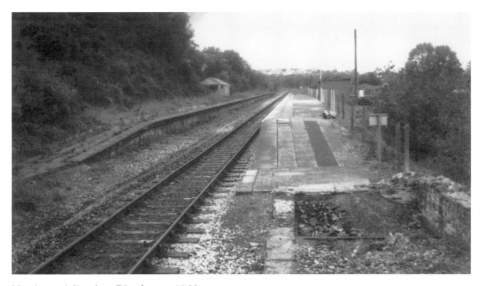

Neglected Station Platform, 1960s
Penryn station in 1960s. The Beeching axe has dropped, the signal box has been demolished. Though the up-line is waiting room still remains, the up-lines themselves have been removed. This little station had been there nearly a hundred years and saw the comings and goings of thousands of people, including the Penryn engineers who left for the war on Good Friday 1915. It was reported that a crowd of 1,000 people was there to see them off including the mayor of Penryn, Benjamin Annear. Before the train left for Southampton the men, who were stationed at Pendennis Castle, were handed pasties and hot cross buns, while the Royal Fusiliers played the National Anthem. (More information about the new station can be found in my other book, *Penryn Through Time*).

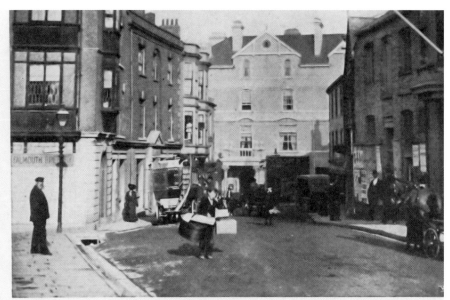

Published by David Murray, 49, Arwenack Street, Falmouth.

Falmouth. Killigrew Street and King's Hotel.

Killigrew Street Penryn Horse Bus

The Penryn horse bus of Penlerick alongside the Falmouth Brewery (later an Odeon cinema and now a Tesco store) on Killigrew Street (the King's Hotel can be seen in the background). The sign written on the back of the bus reads 'Penryn to Falmouth', although no one is sitting on the top deck of the bus at the moment. The Terminus for the horse bus would be Chapman's Hotel in Broad Street.

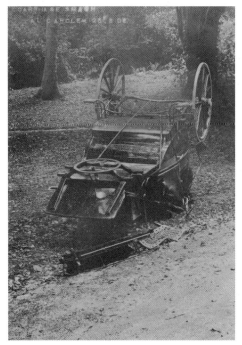

Carriage Wreck, 1902

On 25 August 1902 the horse carriage overturned near Carlew. Newpaper reports suggest that the horse was spooked as it rounded a sharp bend at speed causing the carriage to overturn and spilling passengers over the road. Two lady passengers escaped injury after landing on dead leaves that broke their fall.

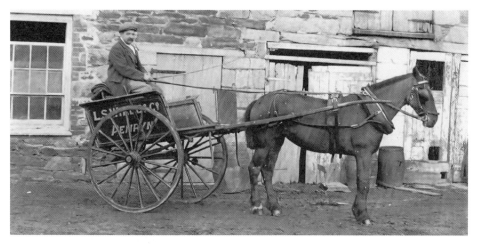

Horse and Cart, St Gluvias Tanners
The sign on the side of the cart reads 'L. S. Willie & Co.'. They were manufacturers of all kinds of sausage castings and buyers of bullock, sheep and pig skins at the Tanyard on the Causeway in Pernryn, almost opposite St Gluvias church. The man holding the reins is John Kneebone, known as 'Tickets', the horse was called Dobbin.

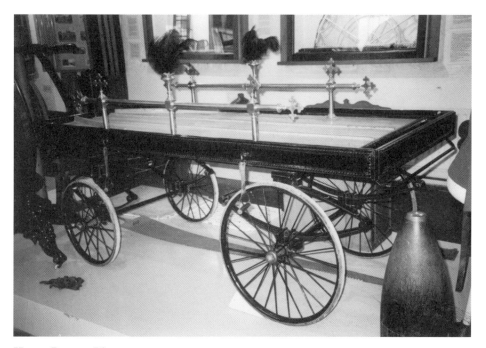

Horse Drawn Bier
Above is a horse drawn funeral bier belonging to the borough of Penryn. The bier was made by Tallack & Co., who were a well established firm of wheelwrights in the college area of Penryn. They were mentioned in 1878 and described as coach builders by 1939. This hearse was probably last used for the funeral of Mr J. H. Buckingham, a local builder, in the early 1930s. He regarded the new motorised hearses as being uncivilised. Alf Bennett was the undertaker (the bier can be seen in the town's museum).

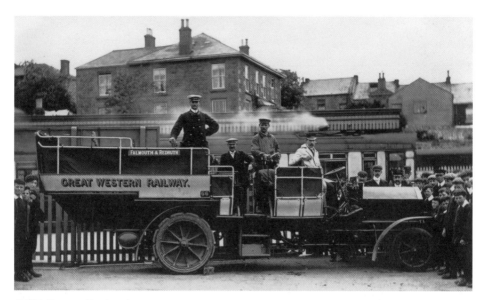

GWR Bus at Redruth

The registered number of this Miles-Daimler 1906 GWR bus is AF 192. It first started life as a double-decker when it was fitted (as seen here) with an observation body. This photograph was taken at Redruth railway station when on the Falmouth run passing through Lanner, Ponsanooth and Penryn. Having solid tyres and being chain driven, the bus only moves when the large stone or brick has been moved from in front of the rear wheel. What a lovely ride in fine weather.

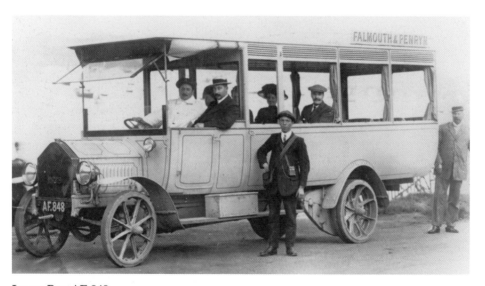

Lacre Bus AF 848

Above is a 30 hp Lacre (registered number AF 848) believed to be on its inaugural run in 1912. The bus was owned by Mr Rickard (not in the photograph) at the beginning of the Penryn-Falmouth Bus Co. and took the place of the jersey cars. Entry was made by a half-door on the other side, and passengers were seated in rows like a toast rack that would hold a maximum of twenty passengers. The bus was chain driven to the back wheels and ran on solid rubber tyres on wooden wheels, it also had bell-shaped head and side lamps.

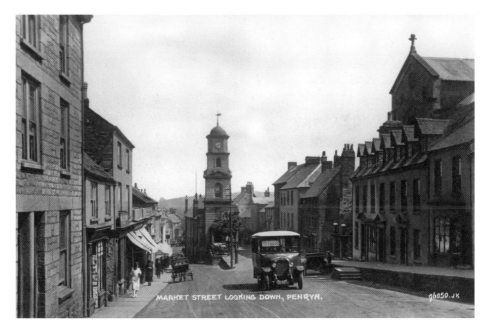

Bus in Penryn Market Street

Above is another photograph of the Penryn-Falmouth Motor Co.'s twenty-seater AF 8520 bus seen here in the main street of Penryn around 1924 still owned by T. G. Rickard. They ran a regular bus service daily every half hour.

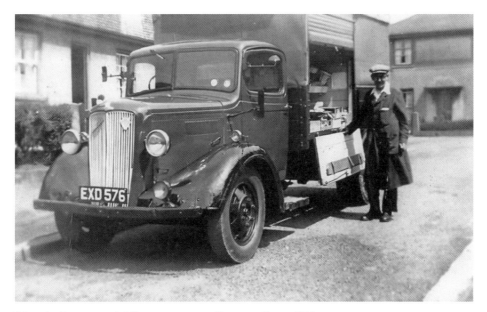

Morris Commercial Lorry, seen at Penryn Council Estate

A Morris Commercial lorry pictured here at a Penryn council estate. The lorry was owned by Willie Blank, a general dealer and greengrocer, until he sold it to David Wiles. The vehicle is very reliable for this type of work, has an up country number and has been fitted with lamps to ensure that he is well equipped for night work.

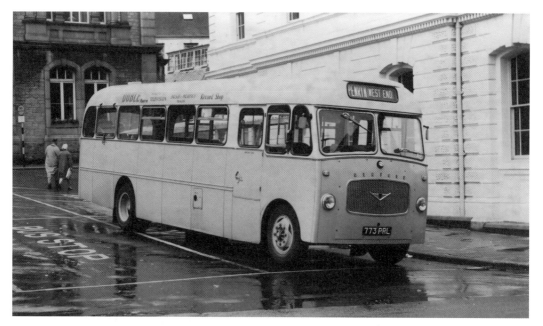

Bedford Bus, seen at Falmouth Moor

The photograph above shows a Bedford Duple waiting in the rain on Falmouth Moor to leave for Penryn West End. It belongs to Harry Oxford and has a nice Cornish number plate (773 PRL) that dates it as the early 1960s. It is advertising Doubles, a Penryn shop that sold not only records but also Bush and Murphy televisions.

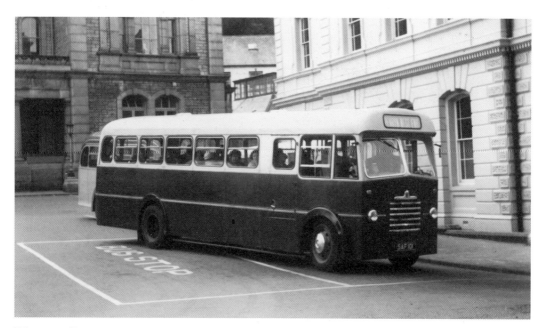

Kinsman Bus, 1950s

An earlier Bedford Duple in almost the same place as the one in the previous image. The SAF 101 pictured here belongs to Charlie Kinsman of Ponsanooth is again destined for Penryn West End.

CHAPTER FOUR

Sport

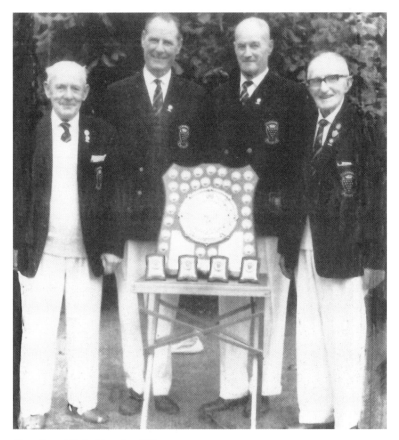

Penryn Bowling Club Trophy Winners
Bowls has been played in Penryn for hundreds of years either on or near the present site, next to the memorial gardens. Several references to the bowling green and the cost of maintaining it appeared in the town's account books for 1652–1795. Even before that, in 1546, a licence was issued to Rauf Couche to keep bowling and other games within Penryn. Seen here are the trophy winners of the 1968 Cornish Championship: Bert Meagor, Roy Pentecost, Percy Palin, and Tom Hughes.

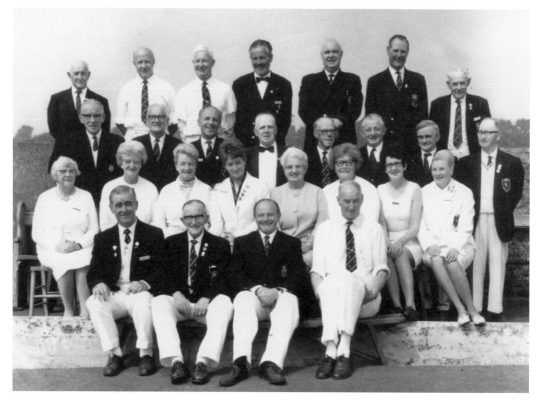

Penryn Bowling Club

A well attended meeting was held in Penryn's town hall and presided over by J. C. Annear in 1931 to consider proposals to form a bowling club. But they had difficulty in finding a suitable site on which to lay a green. It was mentioned again the following year, though no more was achieved. Time passed by, the war came and went, Penryn was bombed and many people killed and the site was later cleared. At long last, the time was ripe for Penryn to have its own bowling green. Soon after, a memorial garden was planted and dedicated to the war heroes that died. And so bowls in Penryn came full circle, returning to its humble origins in the sixteenth century. The photograph above shows some of the members of the present bowling club. Back row: unknown, unknown, George Cray, John Harrison, unknown, Roy Pentecost, Bert Meagor. Third row: Jacker Warn, unknown, Harold Short, W. Walker, Tom, Jose, Eric Eva, unknown. Second row: Mrs Palin, Cary Cray, Vi Harrison, Gwen Daniels, K. Hitchens, Val Stanton, Joan Chegwidden, unknown. Front row: Ron Thomas, Tom Hughes, Bedford Daniels, Percy Palin.

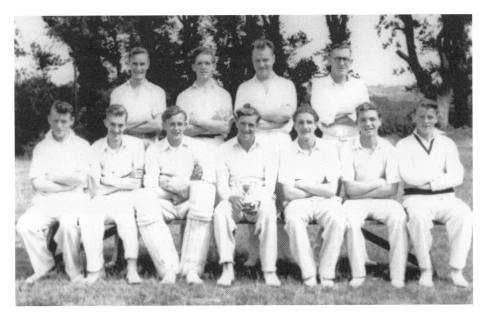

Penryn Cricket Club, 1950s

The first cricket club in Penryn was recorded in 1878. It did not last long, however, and another club was formed in 1881. The new team played on grounds near the railway station, almost within walking distance of it. The photograph above shows the whole team. Back row: Fred Horsefall, Cyril Hancock, Geoff Burroll, Fred Rollison. Front row: Jack Pollard, Monty Smith. Bernard Cox (wicket Keeper) Alf Kerslake, Gynn Nicholls, Noel Meagor, Jim Pollard.

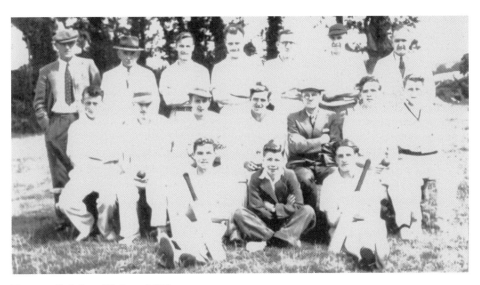

Penryn Cricket Club, *c.* 1950s

Above: 1950s the Penryn Cricket Club can be seen displaying an enormous solid-silver-cup that they had just won. The players are: Back row: Bernard Bishop, unknown, Fred Horesfall, Geoff Burrell R. Rollason. unknown, Horace Hancock. Front row: Jim Pollard, Monty Smith, Bernard Cox, Alf Kerslake (wicket keeper), Stanley Jewell (reporter), Noel Hancock, Jack Pollard. Sitting: Noel Meagor, Clive Sampson, Glynn Nicholls.

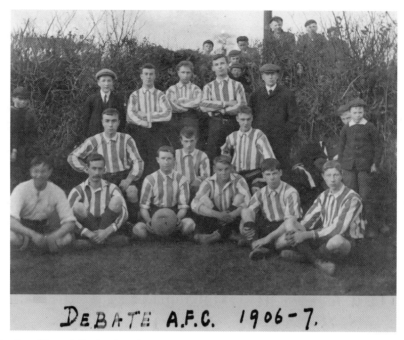

St Gluvias Church Debating Society Association FC 1906–07

Dated 1907, this postcard shows the debating association football club of 1906–07. The postcard was sent from Penryn to Flushing. The inscription on the back reads. 'Here is a panel of debaters ... They have only lost six matches of twenty two, not a bad record is it?' I wonder if Miss Hallett (who the card was sent to) had a relation in the team?

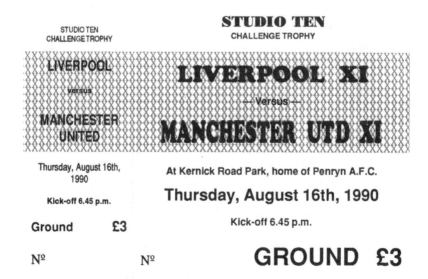

Liverpool FC vs Manchester United

Who would have thought that two mighty teams like these would play an evening demonstration game in little Penryn? They only came down on a trip, but ended the match with a draw.

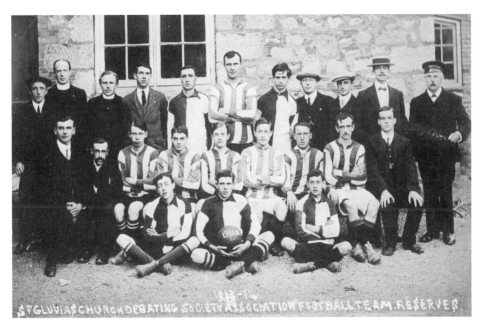

St Gluvias Church Debating Society Association FC, 1913–14

Above A nice postcard of the St Gluvias Church Debating Society Association football team reserve team of 1913–14. I often wonder why the players are wearing two types of shirt.

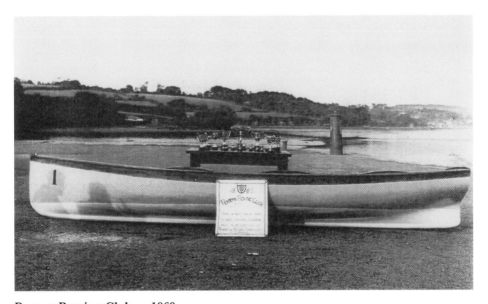

Penryn Rowing Club, *c.* 1960

Penryn Rowing Club dates back to around 1960, they can be seen here with a table full of trophies that they must have won that year seen here on Exchequer Quay. The first rowing club was formed in Penryn in 1868. Their first boat was a thirty-four-foot skiff built by F. Holmes and named *Challenged*. A more recent rowing club was formed by Harry Jennings and Les Hilder. They used the old Salvation Army Hall in the main street to construct and store the boat when it was not in use.

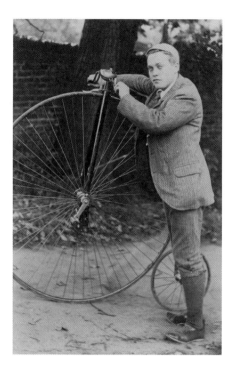

Penny Farthing, 1895
A Cycling Club was formed in Penryn in
1881 when J. Tregaskis was elected captain.
This photograph was taken around 1895 by
R. C. Tremayne showing a gentleman with a
fifty-two-inch ordinary (penny farthing) wearing
the correct garments so that his trousers would
not tangle with the spokes of the front wheel,
and has a 'spoon' brake and upside down bell.

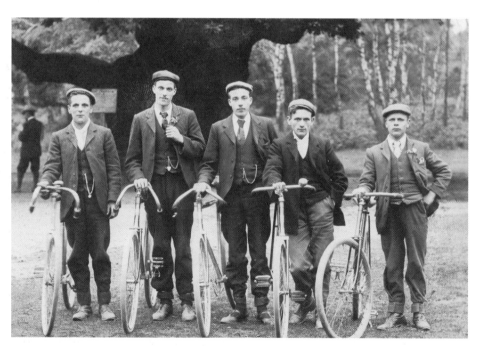

Five Men of the Penryn Cycle Club
This photograph, which could have been taken in around 1900, shows the Penryn Cycle Club.
What lovely cycles they have between them; the second and third are racing machines. The second
one has special pedals similar to the one on the extreme right, which is not a racing machine. It
is a pity that they do not have bells, though three riders are carrying gold watches and chains.

Billy Easom, *c.* 1920

On the reverse of this photograph is written 'Bille Easom, Penryn'. I wonder whether he is related to William John Easom, a cycle maker and car dealer in Market St. He is seen here with his cycle, which has a spoon brake and no bell. Behind him is a Model T Ford, but not a brass radiator model.

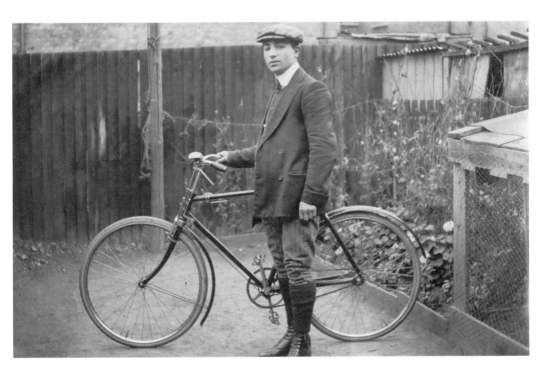

Man with Bicycle, *c.* 1920

Above: A gentleman with a three speed safety bicycle. The photographer was R. C. Tremayne. With pull-up brakes and a Lucas bell, it is either brand new on well looked after. He may even be a member of the Penryn cycle Club of which J. M. Thomas was the secretary.

Penryn Rugby Football Club.

A SMOKING CONCERT

In connection with the above Club will be held in the

Town Hall, Wednesday Evening, July 13th.

☞ ALL MEMBERS INVITED.

J. M. JOHNS, Hon. Sec.

Smoking Concert Advert
In July 1910 the *Borough Times* advertised a smoking concert in the town hall on the evening of 13 July stating that all members were invited by J. M. Johns Hon. Sec.

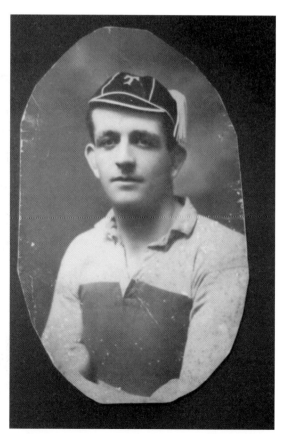

Penryn Rugby Club I
Formed in 1872, Penryn Rugby Club was one of the oldest rugby clubs in Cornwall. The team played their games at Green Lane. Emigrating miners later forced it to disband in 1888. It reformed again in 1893, through one player 'Mashie' Collins. George Jago captained Cornwall in 1927 and one player E. E. Richards (seen to the left), also played for Plymouth Albion and later went on to play for England.

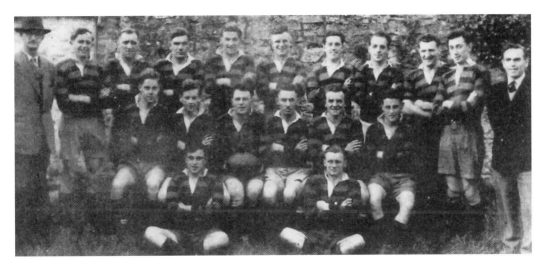

Penryn Rugby Club II
Penryn Rugby Club as they were enjoying their best ever season in 1951/52. They are back row:
N. Barrett (hon sec) B. Cocks, R. Head, J. Parry, R. Edney, R. Rogers. J. O'Leary, Ted. Rose, I. Richards,
L. Roff, J. Plummer (team sec). Middle row: R. Edmons. P. Williams, A. Martin, unknown, unknown,
M. Keast. Sitting: R. Plummer, R. Paul.

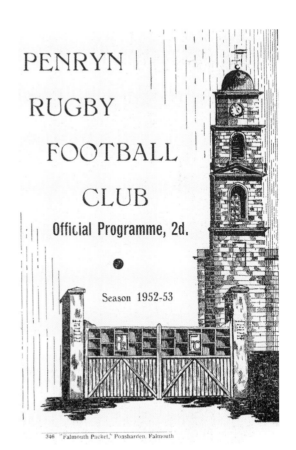

PENRYN

RUGBY

FOOTBALL

CLUB

Official Programme, 2d.

Season 1952-53

346 "Falmouth Packet," Ponsharden. Falmouth

Penryn RFC Programme

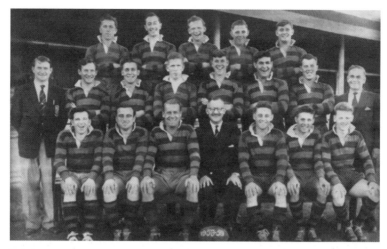

Penryn RFC, 1958/59

After the Second World War, the Penryn Rugby Club bought and levelled the pitch at Parkangue where they played. Under the pretence of free admission passes to the matches, B. D. Williams, treasurer of the club and also headmaster of the council school, had us boys picking up stones before seeding the pitch and giving it a new surface. Needless to say I am still waiting for mine more than sixty five years later. In this photograph of the 1958/59 team the players are: Back row: Alan Ahens, Les Roff, Tony Toy, Donald Peters, Roger Harris. Middle row: Barry Quintrell, Michael Edwards, Derek George, Brian Young, Graham Bate, Michael Kneebone, Brian Bate, Jack Plummer. Front row: Bobby Sewell, Raymond Plummer, John Cobner, J. R. Edwards, Maurice Keast, Brian Mallett, Paul Williams.

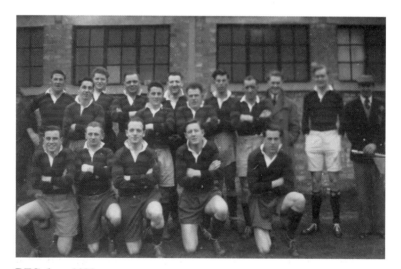

Penryn RFC, late 1950s

The pitch was later named the Memorial Grounds after the players who died in the both world wars. The first game was against Aberavon in Sept 1947. This photograph shows Penryn players and officials from the late 1950s. Back row: Ron Edney, Ken Blackmore, unknown, Richards, unknown Martin, Maurice Keast, Ivan Richards, Alf Martin, B. Bate. Pippy Head, Referee (with hands in his pockets wearing a Penryn Shirt), Barry Quintrell (linesman). Front row: Raymond Plummer, Raymond Paul, Ted Rose, Roger Hosen, Alan Ahens.

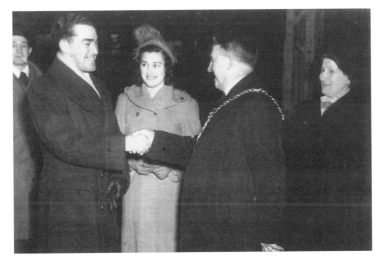

Victor Geoge Roberts

Victor George Roberts and his wife being greeted by Penryn's mayor and mayoress, Mr and Mrs Jennings at Truro station on his return to the town after playing for England against France in 1947. He captained Penryn, Cornwall, England, and the British Lions against New Zealand. He won sixteen English caps between 1947 and 1956. Also in the picture is George Jago who was a good county player.

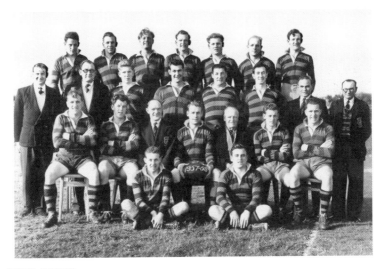

Penryn RFC, 1957/8 team

Other players from the Penryn Rugby Football Club that made the grade and played for England include Roger Hosen, who had a tremendous kick, making the big, wet leather ball go some distance (with today's lighter balls I am sure it would travel the distance of the pitch); Ken Plummer, a very fast winger who had a few caps, as did Roger Harris who was Roger Pullen's understudy for the England hooker. This photograph shows the 1957/8 team took some beating. Back row: Maurice Keast. Derek George, Paddy Orkney, Tony Toy, Robin Cumow, Ted Rose, Michael Edwards. Middle row: Barry Quintrell, B. D. Williams, Brian Young, Michael Kneebone, Ron Edney, Les Roff, Jack Plummer, Lloyd Vincent. Front row: Pippy Head, Brian Bate, Doctor Tinkler, John Cobner, unknown, Paul Williams, Alan Ahens. Sitting: Brian Mallett, Raymond Plummer.

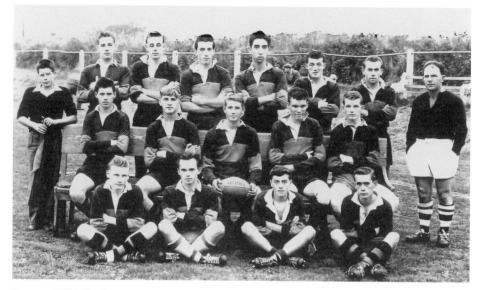

Penryn RFC Juniors, 1960

Above: A group of younger players who hope one day to play for Penryn's senior team: Back row: Peter Simmons, Ronnie Young, Barry Nicholls, David Hartfield, Lionel Tregonning, Colin Bolitho, Alf Martin, (referee, poacher turned gamekeeper). Middle row: Clive Chin, Sam Sloggett, Colin Kneebone, Robert Jackson (captain) David Blake, John Bastian. Sitting: Brian Stephens, Tony Pascoe, Shaun Mooney, Keith Richards.

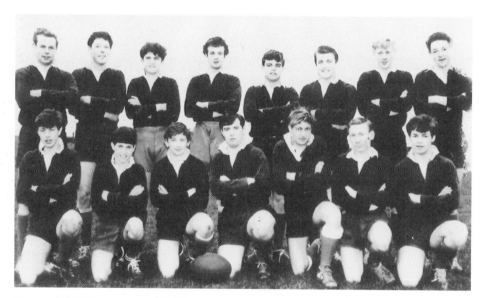

Penryn RFC Colts, early 1961/2

Above: The boys of the Penryn RFC Colts team of the 1961/2 season. On Good Friday they beat Camborne Colts 6-0 with two penalty goals scored by Peter Gedge to establish their home record. Back row: T. Rogers, Jeff Inglehart, Neil Young, M. Collins, John Mills, John Penn, B. Simpson, S. Simmons. Front row: G. Osborne, G. Bray, Peter Gedge, G. Pidwell (captain) David Simms, Barry Stevens, Tim Eustice.

CHAPTER FIVE

Outlying Villages

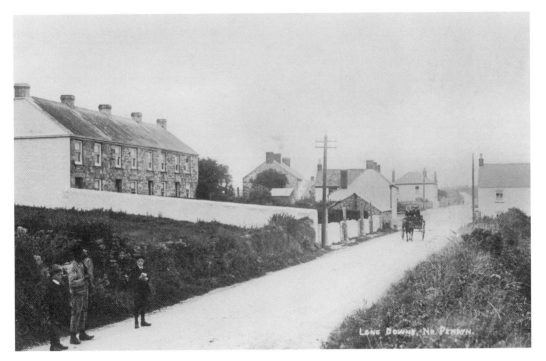

Mabe, near Penryn

Mabe is a little village on the Helston road three miles from Penryn, although small in size it has a sub post office that was managed in 1910 (when this photograph was taken) by Thomas Richards. It has a small number of houses and a cluster of cottages, where a large proportion of the local inhabitants lived who were employed in the granite quarries. The photograph shows how narrow the road was at a time when a lovely little horse drawn cart was the only vehicle to be seen.

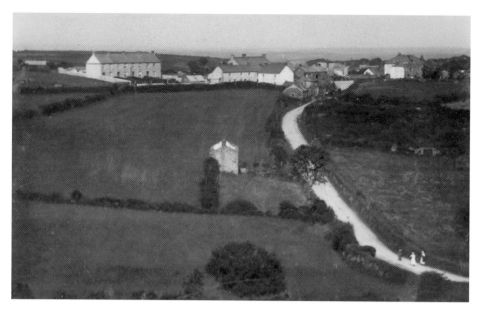

Three People at the Long Downs
A distant view of the same village, perhaps from the same period. Three ladies can be seen out walking in their long flowing dresses.

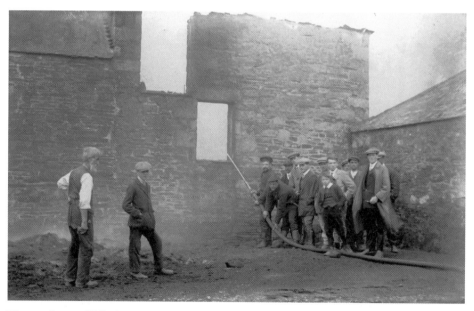

Fire at Anton Hill, 1914
The church of St Mabe is situated on high ground. It has five bells that were cast in 1744 and later recast in 1877, the south door is of Norman origin. The church was damaged by lighting in 1866 and thoroughly restored in 1868 at a cost of £1,400. In 1914 there was a huge fire at Anton Hill, the seat of John Kinsman esq., which occupied thirty acres situated 500 feet above sea level and commanded extensive views over the surrounding countryside, overlooking both Penryn and Falmouth. The picture shows firemen attending the fire in 1914.

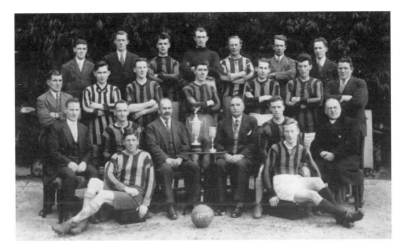

Mabe AFC, 1929/30

The Mabe Association Football Club, winners of the Lockhart Cup and Goldman Cup, who were the champions of the Falmouth and District Football League in the 1929/30 season. Back row: E. J. Tresidder, L. Symons, P. Kessell, E. Francis, V. Rolling, L. Mitchell, J. Tremayne. Middle row standing: D. Collins, G. L. Rowe, N. R. Lowe, (captain) H. C. Proctor, H. P. Francis, W. Grigg, Jas Knowles. Front row seated: R. Kessell, A. W. Blair, J. Matthews. (chairman) M. Longfield, (president) F. McLeod, Revd D. Atkinson, (vice president). Seated: A. F. McLeod, J. Collins.

Mabe Elementary School I

The Mabe public mixed elementary school was enlarged in 1872 at a cost of £85 and then again in 1895, this time costing £100. A staggering £400 was spent in 1911 to enlarge it once again. By 1925 it held 140 children. The photograph above shows Mabe school in 1925. Back row (l to r): Agnes Paul, Phyllis Rashleigh, Lily Jenkin, Phyllis Andrew, Rose Tozer, Kitty Rashleigh, Rica Pascoe, Joan Beard, Doris Richards, Mr Jarvis Putt (head). Middle row (l to r): Arthur Rogers, Albert Pascoe, Doris Collins, Hester Kemp, Elsie Paget, Eunice Winn, Audrey Kessell, Kath Rogers, Leslie Brush, Leonard Spargo. Front row (l to r): Leonard Mudge, Ernest Sanders, Howard Gluyas, Jack Jewell, Ronald Nicholls, Fred Beard, Robert Medlyn.

Mabe School II

Mabe school at about the same time as overleaf, around 1925. The school was under the control of the Penryn-Falmouth District Education Committee. Miss M. A. Cann was the secretary, she had her office in the old Grammar School Falmouth. Back row: Frank Collins, Ted Spargo, Rose Rowe, Cliff Rowe, Lenard Spargo, Harold Saunders, Mr James Putt (teacher). Second row: Pete Spargo, Lilly Collins, Bessie Richards, unknown, Mona Pellow, Mary Richards, Thursa Russell, Dorothy Dunston, Tom white. Third row: Kathleen Mathews, Marjorie Rowe, Pearl Kessell, Audrey Kessell, Muriel Thomas, Madaline Toney Muriel Spargo. Bottom row: Freddie Beard, Cliff Thomas, unknown, Harold Thomas, Ronald Symonns, Leslie Brush.

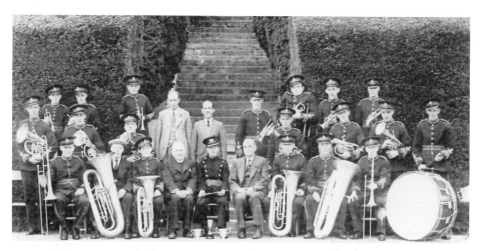

Mabe Band, 1937

The Mabe prize winning band at Tremough in 1937 giving an open air concert. Back row: S. Pascoe, Jimmy Richards, Donald Jenkin, Ted Spargo, Dick Cowdell. Middle row: Cecil Spargo, Lennard Spargo, Edwin Sandals, Fred Row, unknown, Eddy Sanders, Sid Pascoe, unknown, Jack Gluyas. Front row: Donald Francis, Ted Murton, unknown, Revd D Atkinson C. Dawe (bandmaster) unknown, Charlie Hosen, F. Doney, B. Taylor. Ted Murton is either a new addition still waiting for his uniform or was a guest player for the day.

Mabe Amateur Dramatic Society, *c.* 1950

The Mabe Amateur Dramatic Society of 1950. From left to right the players are: Jean Anderson, June Young (carnival queen) Phyllis Hazelstine, Keith Bryant, (page boy), Dave Ferris, (mace-bearer) George Burley (carnival king) unknown (mace-bearer) L. Nesbitt (outgoing carnival king).

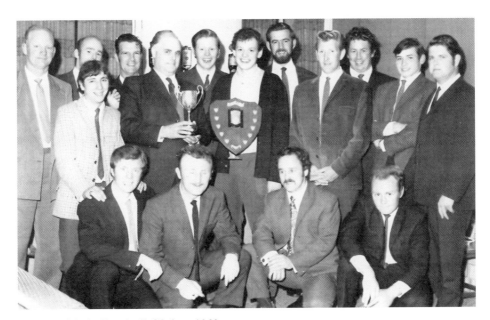

Mabe Athletic Football Club *c.* 1960s

The men of the Mabe Athletic Football Club, seen here after winning the local district league, cup and shield. Standing: Keith Cardell, Albert Thomas (in front with light jacket) Michael May, Jock Logan, Ted Spargo (chairman), Paul Nesbitt, Joe Keates, (captain) John Collins, Peter Parsons, Harry Jennings, Roy Trewella. Keith Bryant. Sitting: Spike Riley, D Williams, Terry Percival, Tony Bowers.

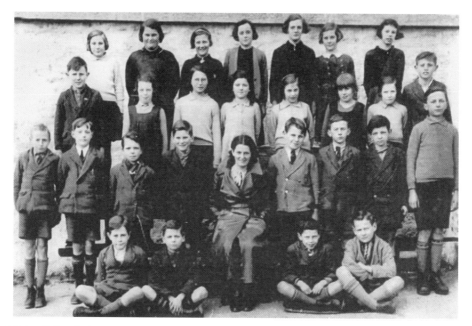

Mabe School, 1936
Back row: J. Kessell, O. Richards, E. Boulton, E. Rashleigh S. Sanders, J. Symons, E. Dunston.
Middle row: D. Symons, unknown, M. Richards, E. Vivian, M. Kitto, N. Thomas, F. Jenkin,
D. Nicholls, Front row: G. Thomas, H. Heam, C. Johns, H. Lowe, Miss Delbridge, N. Hocking,
A. Beard, unknown, W. Dennis. Sitting front: K. Goodman, unknown, K. Rolling, T. Burley.

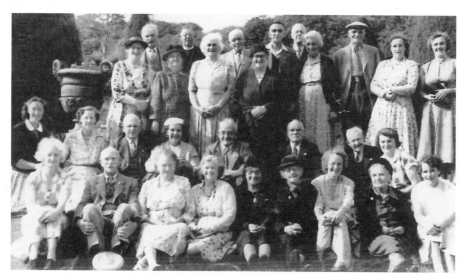

Mabe Residents
The residents of Mabe. Back row: Miss Read, Mr Teague, Mrs Dunstan, Revd Henchy,
Mrs Spargo, J. Warren, S. Warren, Mr Brazier, Mr Meuton Mrs Brazier, A. Berryman,
Mrs Theobald, Mrs Dale. Middle row: E. Dunstan, Mrs Collet, J. Spargo, Mrs Richards,
E. Warren, Mr Pencavil, Mr Roberts, Mrs Lavers. Front row: I Knowles, Mr Dingle, Mrs Chard,
Mrs Dingle, Mrs Pascoe, Mrs Toy, Isabel unknown, Mrs Simms, Mrs Pascoe.

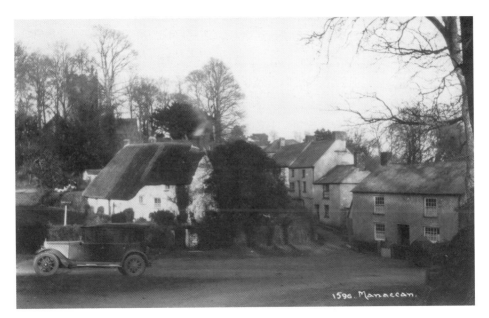

Manaccan, *c.* 1928

Manaccan is a charming village south of the Helford River, seven miles west of Penryn. A large 1924 Albert Limousine is parked alongside a garage sign, outside a white walled thatched cottage, with a glimpse of the church through the trees that dates this image to around 1928.

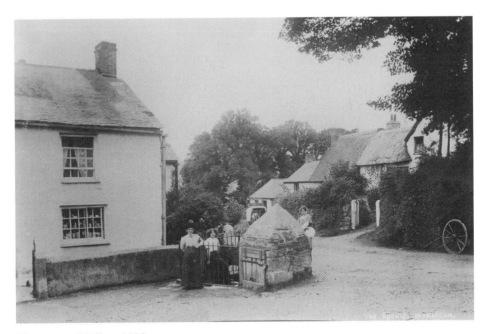

Manaccan Well, *c.* 1910

This charming shot of Manaccan in the spring shows a small group of long skirted ladies quite near to what looks like the village well. Judging by the objects in the bottom window of the house, the ladies could be outside the village shop. One small horse trap has been abandoned and another horse-drawn cart is seen behind the well.

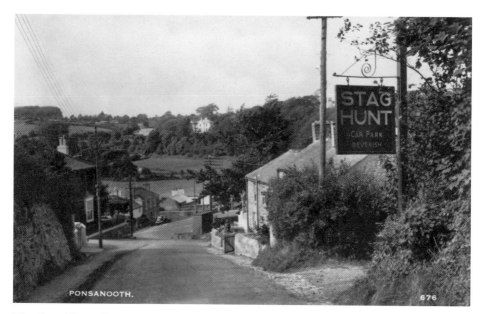

The Stag Hunt, Ponsanooth

Ponsanooth is a large village two to three miles outside Penryn on the Redruth road. The Stag Hunt is the principle public house here and sells Devenish beers that are brewed in Redruth. This is a photograph of the old road, now the rear of the public house, taken in the 1950s. Unlike today there is only one car in view.

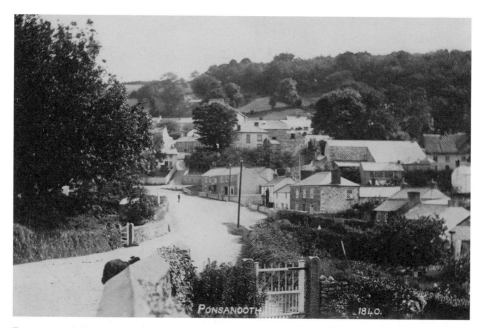

Ponsanooth I

This photograph, taken in around 1920, looks from the Redruth side of Ponsanooth towards Penryn. A little stream flows beneath the road where the telegraph pole is prominent. Today there are houses on the right (where the trees can be seen).

Ponsanooth Wesleyan Chapel, Interior, 1882

The interior of Ponsanooth Chapel in 1882 with the original pulpit. This type of pulpit was found almost everywhere. This one in particular was replaced at a later date by a large rostrum containing space for several people at one time. The Chapel was erected in around 1880 at a cost of £600 and has seating for 130. The picture shows the preacher and choir.

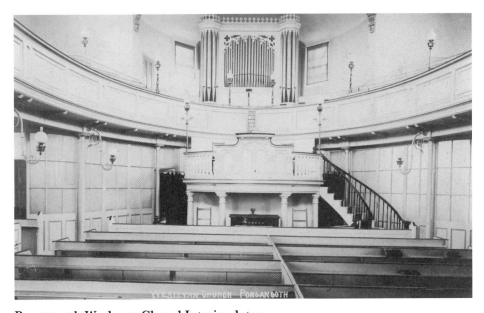

Ponsanooth Wesleyan Chapel Interior, later

The interior of the Wesleyan Chapel Ponsanooth showing the grand organ and upper gallery. As mentioned above, the pulpit has been changed to much bigger rostrum.

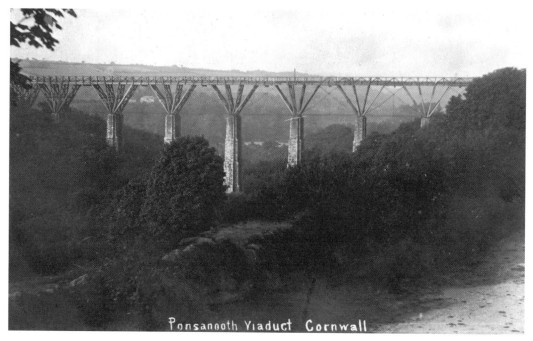

Ponsanooth Viaduct Cornwall

Wooden Viaduct, Ponsanooth

Above is another Isambard Kingdom Brunel wooden bridge that is 140-feet tall at its highest point and 650-feet long. It was built in the 1850s on the Truro to Falmouth branch line here at Ponsanooth. The remains of the wooden bridge can be seen in the photograph below through the stone arch that was introduced when it was replaced in the 1930s. A locomotive can be seen, smoke flowing from the stack, as it makes its way to Penryn in the 1950s.

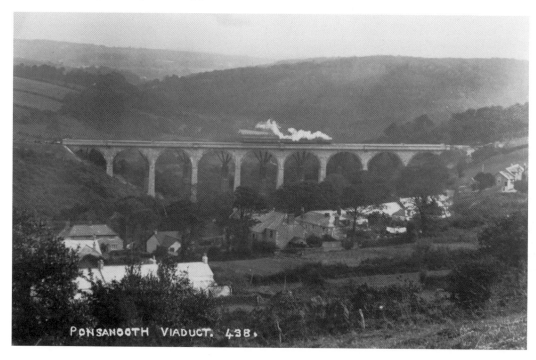

PONSANOOTH VIADUCT. 438.

Ponsanooth, *c.* 1938

The top photograph was taken from the Redruth side of the village and shows a local bus making its way past the Stag Hunt public house, which is behind the tree on the right (the tree is still there on the main road). In the image below, a Standard Flying Nine can be seen about to pass the telephone kiosk on the left making its way to Redruth and out of the village. Woodbines are for sale in the shop on the left.

Budock Waters with Walkers

Budock is a quiet little village around two or three miles from Penryn. The picture shows a lady wearing a long, flowing dress with a bicycle talking to an elderly gentleman with a walking stick who looks as if he is taking his dog for a quiet walk.

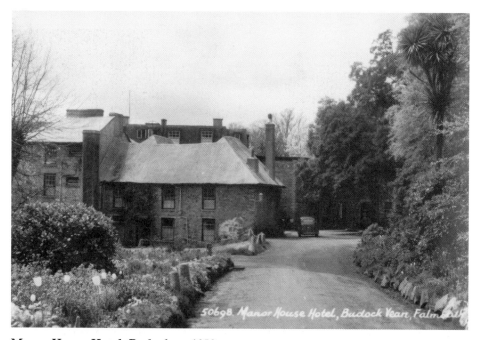

Manor House Hotel, Budock, *c.* 1950

With its own golf course and landing jetty for the sailing patrons, this hotel has it all, lovely views and a warm climate. Judging by the blooming tulips, it is springtime.

The Manor House Hotel

Above is a postcard sent by Bet and Dad to Mum from Falmouth on 8 September 1947 telling her what a wonderful holiday they were having. The Manor House Hotel was a first class establishment and they had been out boating every day. They tell her that Falmouth was absolutely beautiful with pleasant views (the next text must mean something between them) and that they will be returning on Saturday and he will be on board as uaual on sunday.

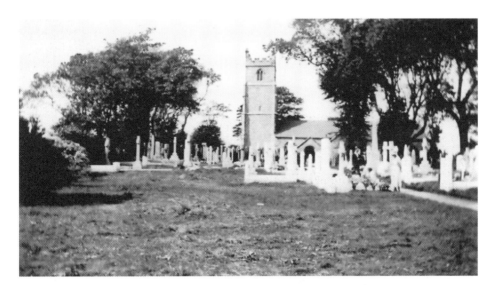

Budock Church, 1935

The church is believed to have been erected prior to 1294 and consists of a chancel, nave, south transept, north aisle and a western tower containing six bells, hung in 1882. It also has a particularly well-restored illuminated oak screen. On the floor of the chancel lies the brass of John Killigrew 1567, the first captain of Pendennis Castle. The rest of the burial ground must now be full.

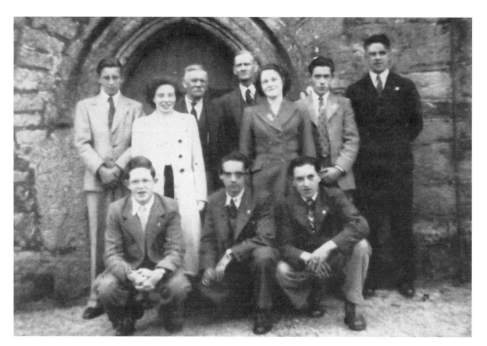

Budock Church Bell-ringers
The bell-ringers at Budock Church, outside the embattled western tower with pinnacles, they are. Back row: Dennis Swadling, Margaret Rowling, Jim Curtis, E. Webber, Marjorie Trevena, George Webber, Maurice Peters. Front row: George Fryer, Peter Welch, Gerald Collins.

A Winter Scene at Trevera Village, 1937
A warm welcome and a good meal awaits the cat Mrs Perham is holding during a snowy moment at Treverva village, near Constantine, watched by Mr Watson. The automobile that can be seen is either a 1937 Wolseley Super Six Series Two or Morris Series Two, really fine car, seen outside her house at Utah.

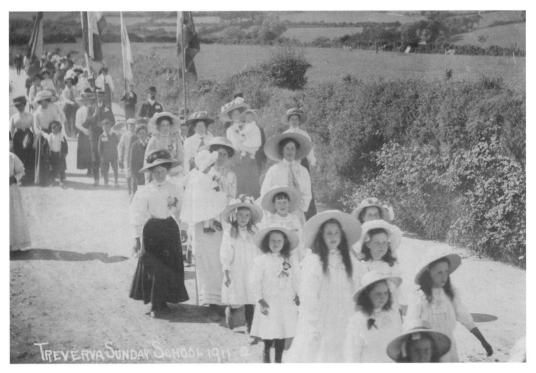

Treverva Sunday School, 1911

Some mothers can be seen carrying their children, all dressed in their Sunday best, off to collect their saffron bun and a bottle of pop. Below, the adults have just arrived at the tea treat field. As in the photograph above they are all wearing hats from flat caps, bowler hats, and straw hats.

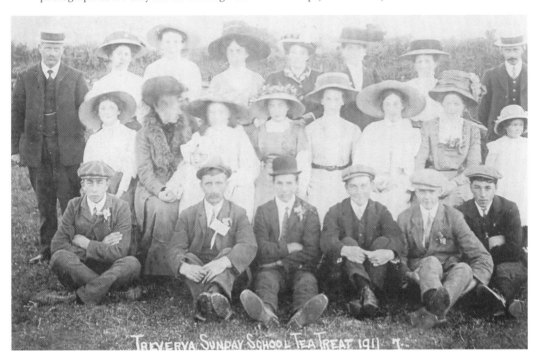

Treverva Woman's Institute, *c*. 1959
Trevera Women's Institute was founded in 1949. Here members are cutting a celebration cake in
1959. They are: Betty Harris, unknown, Lorna Jennings, Doreen Williams Joan Rowe, Donna Bell.

Treverva Woman's Institute
Miss Fanny Reynolds is believed to have been the
headmistress at Constantine girls' school in 1908.
The girls and infants school was built in 1864
for 200 children with an average attendance
of 138 when Miss Edith Stuthridge was mistress.
Prior to that, a boy's school was built in 1836 for
120 children with an average attendance of 59 when
J. Benjamin Seages was master in 1897.

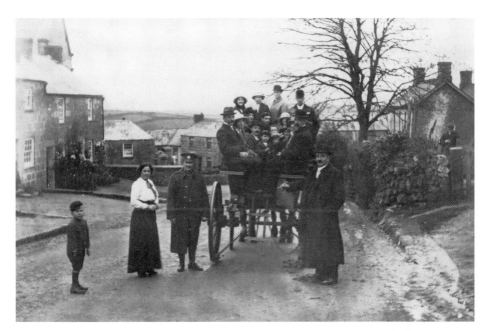

Horse and Carriage, Constantine, *c.* 1910
This photograph shows fourteen people in their finest clothes and children aboard this Jersey car with an army officer standing by at Constantine in around 1910. The gentlemen on the right could be John Courage, a farmer and carrier.

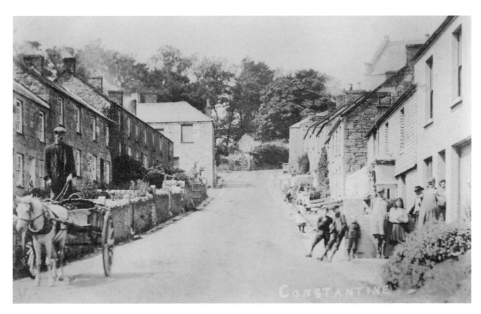

Constantine Fore Street
Constantine Fore Street in the spring sunshine. The main road from Penryn 'six miles' away seems quiet and peaceful enough. The Cornish Arms is at the top of the road; at the time that this photograph was taken Philemon Thomas was landlord in 1911. The top right hand corner shows the Wesleyan Chapel. I wonder what the gentleman bottom left is selling from his horse and cart?

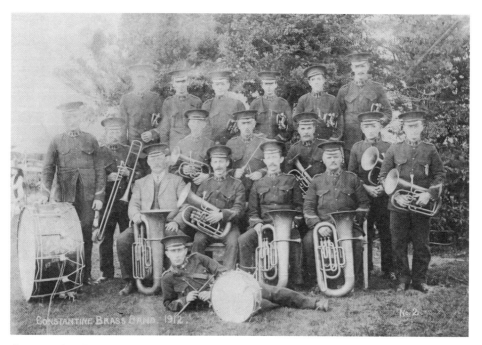

Constantine Brass Band, *c.* 1912

Constantine Brass Band in 1912, only a few of their names are known: Top right: Ed Phillips, Joe Thomas plays the big drum, and Ed Symons plays the trombone, others include Bill Symons, Sid Reynolds, Frank Rashleigh, Charles Cook, Tom Thomas Dave Richards and Bill Sykes. The man sitting down next to the trombone player is wearing his correct cap but the wrong jacket! The conductor may be the gentleman with the baton in the fourth row.

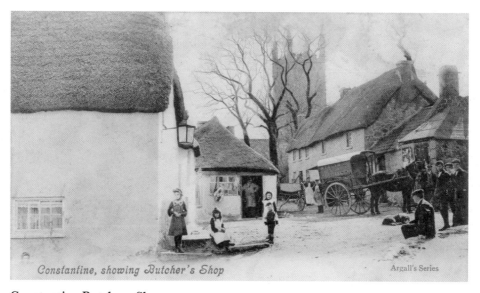

Constantine Butchers Shop

This postcard, sent from Penryn to Helston in 1904, shows William John Medlyn's butchers shop with his horse-drawn delivery cart outside.

Queens Arms, Constantine, *c*. 1950
These thirsty men propping up the bar at the Queens Arms Constantine are drinking bottled beer and enjoying themselves. They include: Ewart Hocking, John Vingoe, Walter Rashleigh, Raymond Rashleigh, Billie Rashleigh, John Rashleigh, Horace Roberts, Henry Phillips, Leslie Williams and Ron Rashleigh.

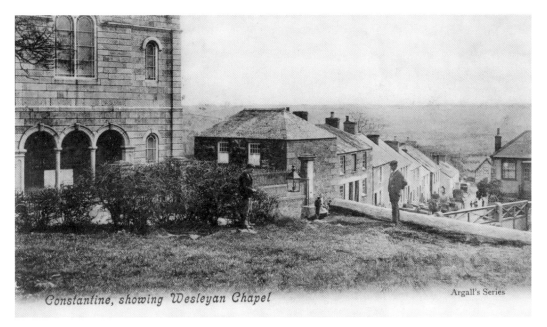

Constantine, showing Wesleyan Chapel

Argall's Series

Constantine Wesleyan Chapel, 1907
The Constantine Wesleyan Chapel at the top end of Fore St. This postcard was sent from this lovely village to Guildford, Surrey on 9 October and was back-stamped 10 October arriving next day. Is it any better today, more than 100 years on?

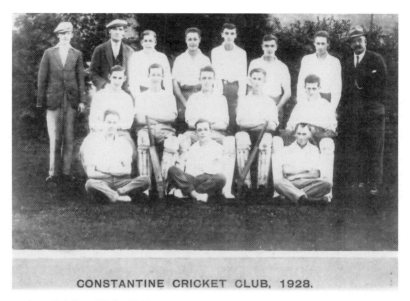

CONSTANTINE CRICKET CLUB, 1928.

Constantine Cricket Club, 1928

The cricket field was given to the Constantine Cricket Club by Mrs Alice Hext in 1922. The first man standing on the left is Henry Saunders, who had a bad accident while working for John Freeman that caused him to lose his right arm. Unable to play, he must have kept the score. The rest of the players are: Back row: Henry Saunders, George Thomas, Edwin Reynolds, Bill Simmons, George Rowe, Harry Phillips (senior) Sidney Hodges. Middle row: Billy Hyde, Horace Hyde, Albert Williams. Crossed legged: Samuel Moyle, Monty Dunstan, William Winn.

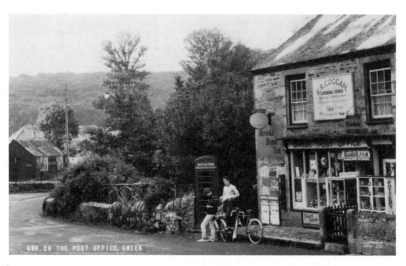

Gweek

Gweek is a village around six or seven miles south of Penryn. Pleasure boats from Falmouth come here bringing their passengers on day trips. This photograph, taken in the early 1960s, shows E. S. Coggans General Store and Post Office, which sold everything from Lyons Brooke Bond tea to Capstan Cigarettes. Hanging outside the store, it is not a satellite dish, but an enamel sign advertising cigarettes.

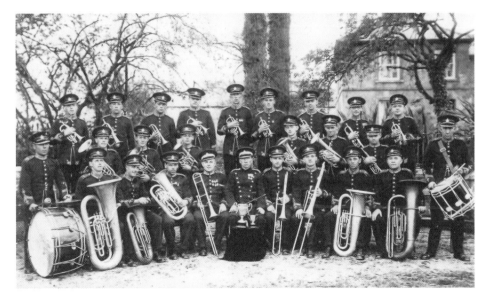

Gweek Silver Band

Gweek Silver Band are resplendent with their gleaming instruments and silver trophies on display, some of the band members are: P. Moyle E. Moyle, J Williams, L. Reynolds, H, Oates, J. Moyle, W. Chainey, M. Jenkin, L. Thomas, C. Goldsworthy, L, Vincent E. Toy, G. Williams, D Moyle, R. Pascoe, W. Williams, W. Richards, A. Moyle, Will Hocking, T. Chainey, R. Pascoe, L. Pascoe, H. Ralph, J. Barnicoat.

Shipwrights Hotel, Helford, 1914

The Shipwrights Hotel at Helford. Helford is a small port with a ferry across the estuary, around three quarters of a mile from its entrance it is deep enough in some places for vessels of 600 tons. Incoming ships would be bringing in timber, lime and manure. Mr Nicholls was the landlord of this establishment when this photograph was taken in 1914.

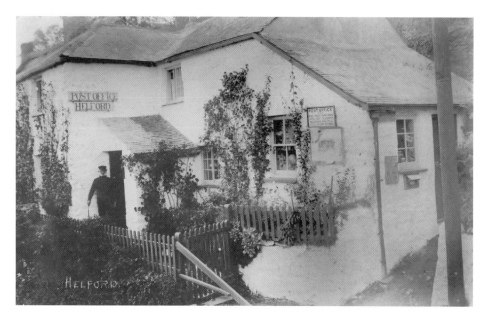

Helford Post Office, 1916

If the gentleman standing in the doorway is the post master he could be Frederick White. The sign on the noticeboard alongside the window full of groceries reads 'Post Office. Money Order Savings Bank. Parcel Post, Telegraph, Insurance Annunity and Express Delivery Business.'

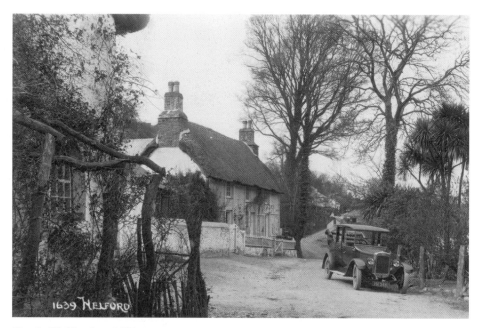

Car in Helford, *c*. 1930

The car is a lovely 1927 Austin 20/4 Marlborough handau. The car must have come from outside of Cornwall as its number plate is not an old Cornish plate (YH 3481). As you can see, the car would not pass its MOT if taken now because the front right tyre is bald. Clearly no rain is expected because the hood of the car has been folded down.

The *Queen of Helford*, c. 1950
The *Queen of Helford*. At the time that the photograph was taken it was the largest cabin cruiser sailing on the river. It seated seventy-five passengers and sailed daily from the Prince of Wales Pier, Falmouth, from 10.00 a.m. An afternoon cruise, which departed at 2.30 p.m. and returned at 6.00 p.m. visited Helford River, Durgan, Ferry Boat Inn Helford village Frenchmans Greek, Duchy Oyster Farm and Port Navas.

Port Navas Oyster Farm, *c.* 1950
A fisherman dredging for oysters at Port Navas Oyster Farm in around 1950. Helford oysters are known throughout the world. Today the oysters are measured by placing them over a measuring ring, if they fall through then they are released and caught again at a later date.

Helford Passage, *c.* 1910

This is the place where the *Queen of the Helford* would stop for a short break on its afternoon cruise, the Ferryboat Inn on the Helford River. In early spring people come here to 'rake for cockles' with a lot of success. This photograph, taken in 1910, shows two men repairing the pot holes in the road, one appears to be struggling with the wheelbarrow.

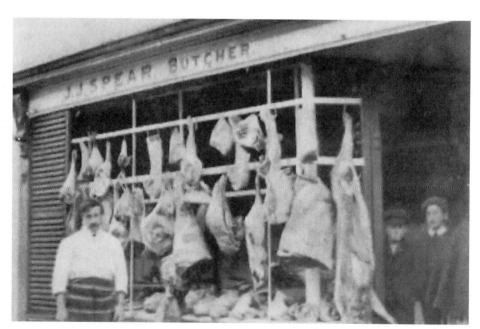

John Spear, the Butcher at Flushing, *c.* 1910

Flushing was in the parliamentary borough of Penryn and Falmouth until the boundary changed. The village is separated from Falmouth by the Penryn River and crossed by ferry boat to Falmouth, with a rowing boat connection to Greenbank late evenings. Flushing is just a short (and lovely) walk from Penryn.

Flushing Pantomimes

Flushing Pantomimes were staged annually between 1950 and 1953 involving most of the village children and a few local adults. Performed in the church hall, they were produced by Agnes North, with help from Anne Reason, Anne Dream, Rose Allen and Santa Claus. Mrs North made a large number of colourful costumes, many from crepe paper. Scenery and props were created by Albert Schenks. The accompanist was Kathleen Furse. They were sponsored by Wills Woodbines and were always home by midnight. Others involved were: S. Lang, R. Arthur, S. Wales, B. Cumow, M. Lauver, A. Spear, D. Brimicombe, M. Mayne, M. Pearce, R. Allen, M. Furse, S & R Clark, E. Bulpin.

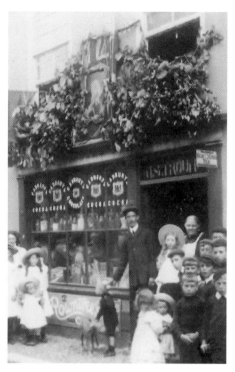

Flushing Sweet Shop, *c.* 1905
The sweet shop of Mr Trounce with a number of children posing for the camera; he must have been giving away sweets. I wonder if it is the owner who is standing in the doorway, about to swivel the young boy's head around to smile at the camera.

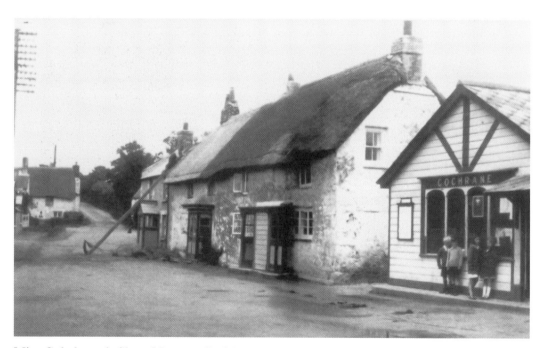

Miss Cohchrane's Shop, Mawnan Smith
Mawnan Smith is a village two miles south of Penryn. Four children can be seen in the photograph standing outside Miss Margaret Cochrane's shop. It looks like it could be a wooden structure where as the cob-built cottages next door is having its thatch roof repaired.

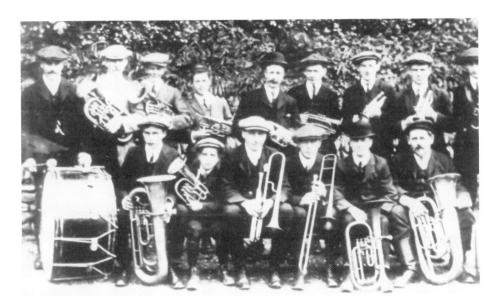

Mawnan Brass Band

Mawnan Brass Band in 1905; it is a pity they do not have a uniform, but they were lucky to have instruments in those days. Mawnan is a delightful little village at the mouth of the Helford River. Back row: C. Tallack, P. Pascoe, A Drew, C. Rickard, John Opie, G Tresise, P. Matson, T. Snowdon, Boss Treneny. Front row: C. Hosen, J. Hosen, H. Rowe, C. Inglehart, S. Rolling, E. Rowe.

Mawnan Smith Scout Group, 1911

This uniformed bunch of enthusiastic young gentlemen with their staffs may be at camp or out on an exercise. Back row: William Collins Scout Master, unknown, C. Cook, William Eddy, unknown, Arthur Sadler. Middle row: Arthur Eddy, Arthur Chinn, Ron Henwood. Front row: A. Eddy, A. Chinn, E. Ivy, E. Moore, L. Eddy.

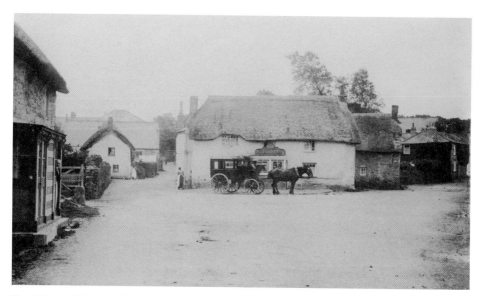

Red Lion, Mawnan Smith, *c.* 1900

In this photograph a carriage can be seen waiting for a patron outside the Red Lion public house at Mawnan Smith in around 1900 where John Peter Sadler was the landlord. All looks quiet and peaceful.

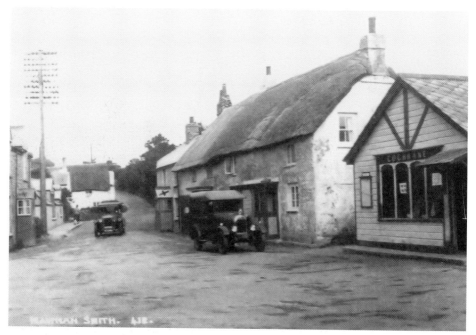

Miss Cohchrane's Shop, Mawnan Smith, 1925

In this photograph from 1925, the children and the gentleman have disappeared from Miss Cochrane's shop and motorised transport has at last reached Mawnan Smith. No doubt both cars have been seen in the village before. Look at the telegraph pole, everyone in the village must have had a phone.

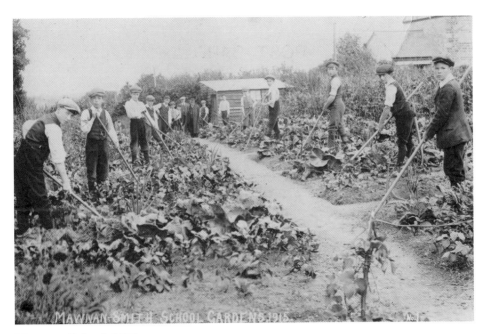

Mawnan School, 1915

Sixteen youngsters have stopped work to pose for this photograph. A mixed school, it was founded in 1834 for 120 children with an average attendance of 102. Stephen Harvey was the headmaster and Miss Ethel Thomas was in charge of the girls. Mrs Ada Choak and Miss Lillian Rashleigh were mistresses at the school.

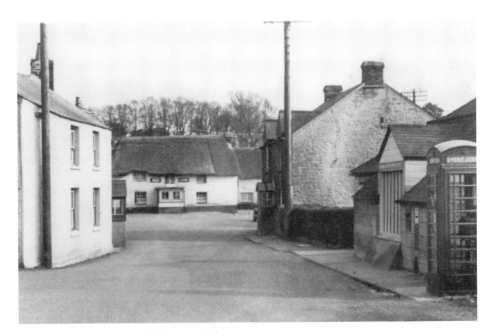

Mawnam Smith Post Office, *c.* 1940

Mawnan Smith post office on the right, next to the K6 telephone box, when Miss Elizabeth Haughton was the post mistress.

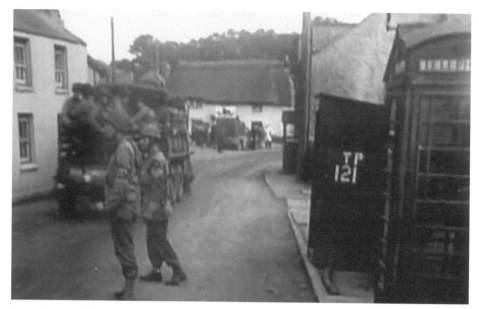

American Military Police Corps Directing Traffic D-Day

June 1944, saw the American Troops that had been stationed all over Cornwall, especially in the west; prepare to leave for Europe, landing at Omaha beach. They had been based all over the Penryn—Falmouth area, looking after the children with gifts of sweets and chewing gum, and older young ladies with nylon stockings as they had plenty of money. Here officers from the American Military Police Corps are directing traffic past the Red Lion at Mawnan Smith.

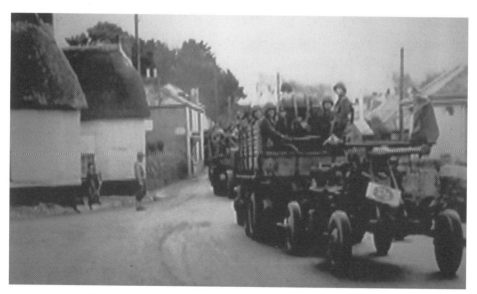

American Soldiers Passing the Red Lion, Mawnam Smith

The American forces had an advantage over the British troops who only earned fourteen shillings a week, the Yanks nearly five times as much at £3 8s 9d. This shot shows the American soldiers towing a gun and carriage heading to the landing craft at Trebah beach they are passing the Red Lion at Mawnan Smith, which is on the left.

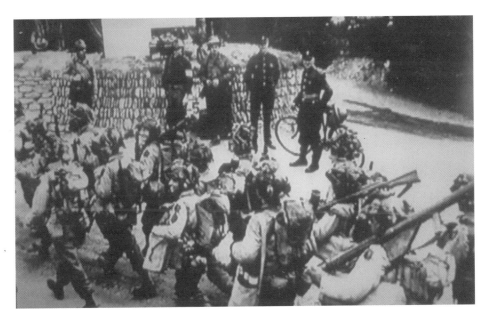

American Soldiers on the March

During the Second World War, camera film was almost impossible to purchase. Copies of photographs were lucky to be obtained in this period. Taken from a bedroom window, this photograph shows the American troops marching through Mawnan Smith, watched by British troops and civilians.

Loading the LSTs

Two LSTs (Landing Ship Tanks) are on each side of the specially built pier (built by a Penryn building firm). These tanks were used to load troops and military vehicles, as this photograph shows. The numbers that can be seen are US539 and US27, the photograph shows men preparing the loading gangways to be put in place.

Operation Overlord

An LST part loaded on an early morning, on the hard standing at Trebah during operation OVERLORD.

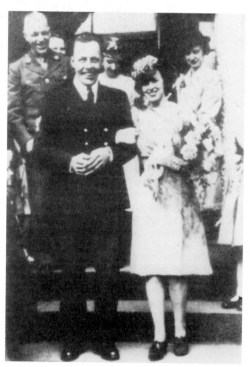

During the War

On a happier note, some of the friendships forged during the war led to marriages and many brides made their way, as our Cornish ancestors did years before them, to the United States. On the left is a photograph of Nellie Retchford and Philip Lee Bishop at their wedding in Penryn Wesleyan Church in May 1944. He was a Naval Reservist and came from Seattle. It was reported in the *Falmouth Packet* at the time that two young Penryn girls were said to be in need of care and protection and were out of control, staying out late and associating themselves with the GIs, who were dealt with by a Military Court.

CHAPTER SIX

Miscellaneous

Penryn Council School 1922/23

The Infant class of 1922/23 Back row: Kathleen Newman, Kathleen Woods, Betty Cosham, Doris Williams, E. Pollard, I. Philpott, J. Tripp, Middle row: Peter Coplin, unknown, Joan Rogers, Megan Pellow, Hazel Pascoe, Gerald Buckingham, Roy Buckingham. Front row: Cyril Richards, unknown, Julie Rule, Elias Williams, Teddy Coe, George Trelowan, Alfred Reed, Teacher Miss Bray.

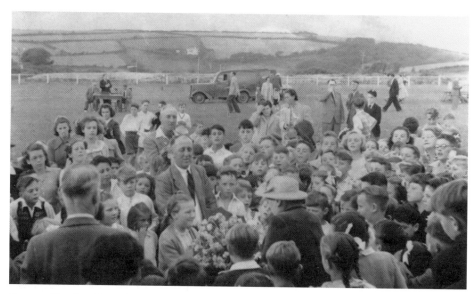

Penryn Rugby Club Crowd, *c*. 1958

This photograph, taken at Penryn Rugby Club, includes some well-known faces: B. D. Williams, club treasurer and headmaster of the council school, Councillor Mr Gwyther alongside him, Ernie Medlyn can be seen greeting Miss Truscott and a young lady presenting by her with a lovely bouquet of flowers.

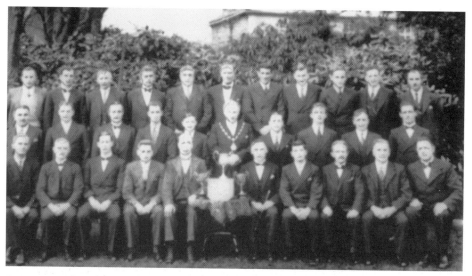

Penryn Choir, 1934

The Penryn Choir of 1934 showing off the silver trophies that they had won under their leader, Philip Dancer. Back row: J. Williams, C. Abrahams, J. Pellow, F. Thomas, H. Keveme, J. Webber, R. Jenkins, L. Hodge, D. Truscott, A. McCleod, W. Newman. Middle row: unknown, W. Medlin, B. Hicks, J. Bray, Mayor A. T. Greenwood, (president) F. Lobb, B. Toy, T. Coombs, A. Olley. Front row: E. Allen, O. Ball, A. Stumbles, (hon. sec.) R. Ralph (chairman) W. Pickles, (deputy conductor) P. T. Dancer (conductor) C. Lobb (pianist) C. Blank (treasurer) H. Hodge, Fred Jacket, (missing E. Williams.)

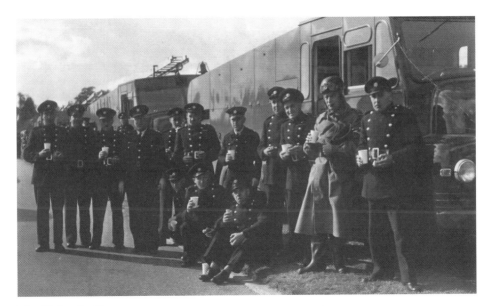

Fire Brigade, Penryn

Built in 1899, the closure of Penryn fire station (at the top of St Thomas Street) was proposed in 1948 but rejected due to local opposition. Penryn's fire station was relocated to Commercial Road in 1981, but amalgamated with the Falmouth branch in April 1996, finally closing the doors to their premises at the bottom of St Gluvias Street. A group of Penryn firemen can be seen in this photograph under Chief Fire Officer Reginald Rogers. The men are: unknown, F. Millman, Reg Rogers, I. Burleigh, Dinky Summers (sub officer) K. Summers, Morley Julian, Arnold Johns, Jerry Andrew (despatch rider) G. Collins. Sitting: Noel Mitchell, unknown.

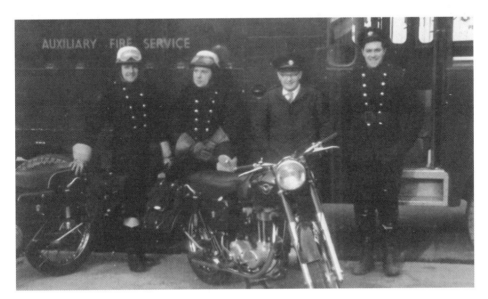

Penryn Firemen *c.* 1960

The Penryn Auxiliary Fire Service Firemen standing alongside their auxiliary fire engine (or Green Goddess) on Commercial Road are: Ray Retallack and Peter Welch, who were dispatch riders with their 350cc Matchless motorcycles; also seen are David Hocking and Tony Kerslake.

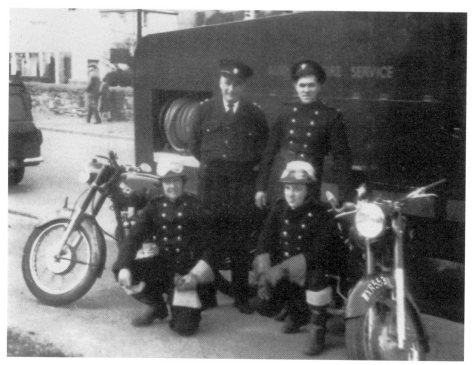

Outside Pemyn Fire Station on Commercial Road
Back row: Station Officer G. Andrews, Tony Kerslake, Front row: R. Retallack, P. Welch.

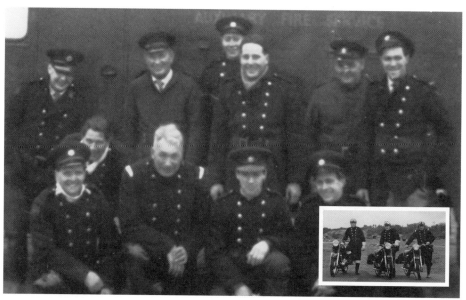

Penryn Fire Brigade
Top row: David Hocking, unknown, R. Menhenitt, Roy Barnicoat, B. Maddson, Tony Kerslake. Front row: R. Retallack, G. Chard, S. Andrew, D. Summers, R. Hallam. (*Inset*)With shining new motorcycles these Penryn Firemen really look the part. They are: R. Retallack, B. Madson, and G. Andrews.

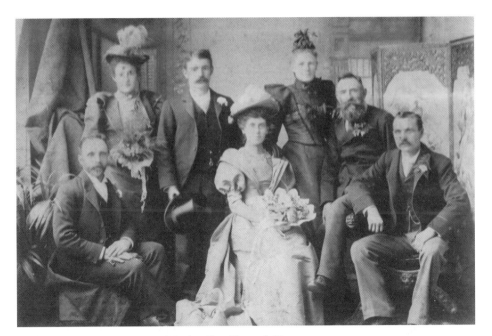

First Wedding at the New Methodist Chapel, Penryn
The first wedding at the newly-built Methodist came a fortnight after opening on the 27th when two members of the choir were married. Tragically the bride died in 1894 of TB, the groom later remarried and became a reverend and ran a nursery garden in Penryn. The wedding photograph shows: (standing) Mabel Whitburn Clemens, E. Clemens (groom) Mrs Clemens (groom's mother). Sitting: J. H. Dunstan, Darcie Moore (bride), Mr Clemens (groom's father), Thomas Trelease Moore (who gave the bride away).

Cornwall's Wonder Dog
This photograph shows Cornwall's Wonder Dog, Tearaway Tim, the winner of many silver trophies. Tim has never been beaten and was a star of *Opportunity Knocks*. He was owned by Joan and Ron Hodge who lived at Strutal Farm near Penryn.

Penryn Creamery, _c._ 1940s

I have been searching for years for photographs of anything about the Penryn creamery. In my last Penryn book, _Penryn Through Time_, there was a picture of the works being demolished. A few weeks after the book was launched, these photos came in the post, with nothing to say who sent them: no letter, nothing. The post mark was from Devon. Thank you whoever you are. I can only assume that the photo of the milk churn was taken inside the creamery. With a little enhancement 'Co-operative Penryn' can be read on the side of the cart along with the word 'milk'.

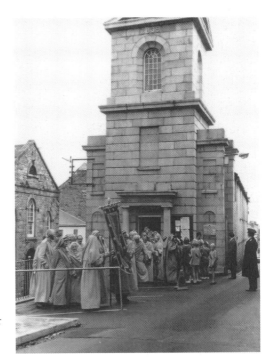

Cornish Goredd, Penryn, 1974

The Druids have come to Penryn for the Cornish Gorsedd in this photograph dated 1974. Here they are leaving the town hall in their long, flowing blue robes carrying a banner and making their way down towards what is left of the old college at Glasney.

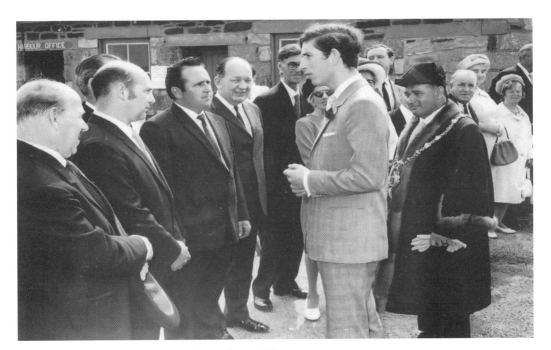

Prince Charles at Penryn Quay, late 1960s

Charles, the young Prince of Wales, came to Penryn in the late 1960s. This photograph was taken on the quay outside the harbour master's office with Mayor Douglas Thomas, seen here talking to Peter Welch and Terry Jennings. Also in the picture is, Stanley Thomas, Harry Burnett, Mr and Mrs Gwyther. Mrs G. Ball, Alan Muirhead, Mr & Mrs Scorse and Mr and Mrs Greenwood can also be glimpsed.

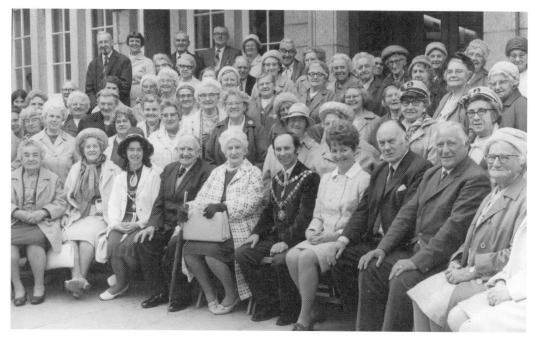

Penryn Old Folks at St Ives, *c.* 1960
The Penryn Old Folks Club enjoying their annual outing. Over 100 members went, in coaches provided by Mr Rickard, to St Ives. They were greeted by Alderman and Mrs M Hocking wearing his chain of office. Penryn's mayor, Douglas Thomas, is not present, but there are two ex-mayors, Mr and Mrs Benny Jennings and Mark Tallack. All must have had a wonderful time.

Head of the Warmington Family Tree
This is a photograph of my grandmother, Minnie, and grandfather, Ernest, who I was named after, taken on the occasion of a family gathering in the summer of 1934. I knew my granny very well, but never met my grandfather as he was killed in an accident at Falmouth Docks shortly after this photograph was taken.

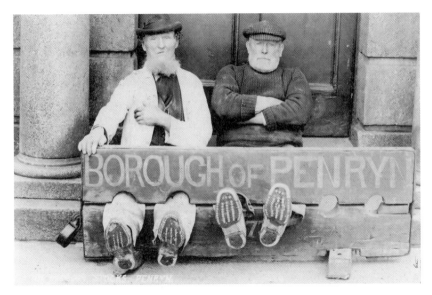

Penryn Stocks

This postcard, dated 1908, was sent to Newton Abbot and shows the borough of Penryn Stocks outside the town hall. As you can see, it will hold up to three people. The bearded gentleman on the left, wearing hobnailed boots, is believed to be Mr Chinn, but I have no idea of the other man's name.

The bottom photograph was taken 'as it says' outside the Old Curiosity Shop in Falmouth. John Burton, the owner of the shop, managed to purchase the stocks. In a thoughtless moment, Penryn town council authorised the mayor to sell the 'lumber' at the Town Hall, selling the stocks for £2 in 1907. No sooner than the bargain had been completed, there was a howl of indignation at the Penryn council. A heated discussion was held at the next council meeting, at which John Burton, in order to allay the ill-feeling, wrote to the local press making the following offer: if three Penryn councillors would consent to be placed in the stocks outside his shop and photographs, he would give them back. The offer was not accepted and the stocks were sold to a Devizes antiquary for a handsome price. It is not known what happened after that, but the stocks can be seen in Penryn museum today.

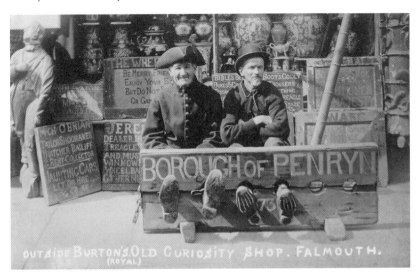

Penryn and the Coinage Towns. To the Kings Most Excellent Matie. The humble petition of the Mayor Burgesses and Inhabitants of the Borough of Penryn:..., *May it therefore please your most Sacred majesty to make the said Town of Penryn a Coinage Town, a fine copy of Penryn's petition of 1682, seven pages, including detailed reasons in support of the claim together with Reasons humbly formed by the Antient Coinage Towns why no patent ought to be granted for the Coynage of Tynn at Penryn,*

Applying to become a Coinage Town

These very, very important documents were in an auction some time ago. Following a long and difficult investigation, I now know who owns them. The owner gave me these copies to use; in a short while they may be for sale again. Below is a hand written letter from Penryn's town clerk 1732.

To His Royal Highness Frederick Prince of Wales Duke of Cornwal Earl of Chester &c

The Petition of the Principal Adventurers and others concerned in Tinn Mines in the Parishes adjacent to the Borough of Penryn.

Humbly Sheweth

That the Borough of Penryn is Environed with Parishes the most productive of Tinn of any in the County of Cornwal Contiguous to the Commodious Harbour of Falmouth and furnished with Wharfs Cranes and all other Conveniencys for Merchantable affairs much Superiour to any Coynage Town in Cornwal.

That your Highnesses Petitioners who are concerned